BLACK AMERICA SERIES

GLYNN COUNTY
GEORGIA

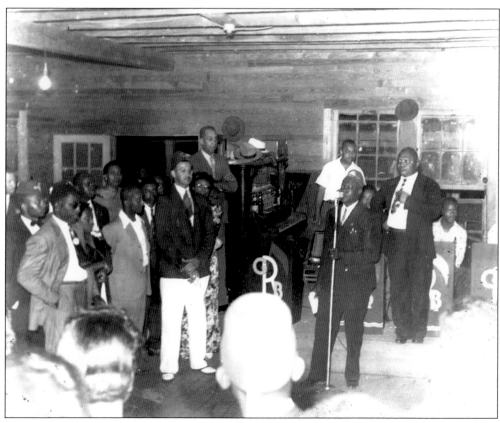

A local fraternal order social gathering is seen here. Some of the participants are Carl Outlaw (white pants), a retired cook at the Cloister and personal cook to President Jimmy Carter during his St. Simons Island visits; Genoa Martin (on the stage near the piano); Henry Dent (far right on the stage); and Willie Searcy (in the doorway to the left). (Courtesy of Willie and Gloria Simmons.)

BLACK AMERICA SERIES

GLYNN COUNTY
GEORGIA

Benjamin Allen

ARCADIA
PUBLISHING

Published by Arcadia Publishing
Charleston, South Carolina

Printed in the United States of America

Library of Congress Catalog Card Number: 2002114924

For all general information contact Arcadia Publishing at:
Telephone 843-853-2070
Fax 843-853-0044
E-mail sales@arcadiapublishing.com
For customer service and orders:
Toll-Free 1-888-313-2665

Visit us on the Internet at www.arcadiapublishing.com

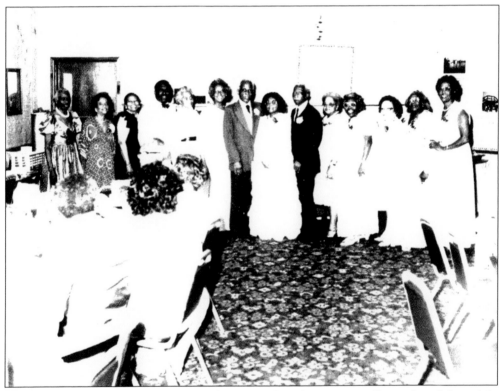

The Colored Memorial class of 1933 celebrates another class reunion. Shown from left to right are two unidentified women, Jenny Flanders, Jasper Barnes, Edwina Blake, unidentified, Pat Gary, Willie Ryals, Thomas Scott, unidentified, Ruby Knight, Mabel Taylor, Carrie Harris, and Carrie Simmons. (Courtesy of Lenora Massey Gary.)

CONTENTS

ACKNOWLEDGMENTS

I am first and foremost indebted to Edward Parrish and Richard Perry, and to the accomplishments of Glynn County's residents. I, and each reader, owe a debt of gratitude to Dr. Charles J. Elmore, chairman of the department of mass communications at Savannah State University, for putting me on the spot and submitting my name to the publishers at Arcadia. I am also grateful to Tisha Dillon, interlibrary loan, archives, and periodicals assistant at Savannah State University for her efforts in securing some rare microfiche. A special thanks goes to the Georgia Historical Society of St. Simons for directing me to the William Mein letter at the Historical Society of Pennsylvania. I also thank Geri Chapman Culbreath for her persistent effort in getting the message out in Glynn County. Finally, I am grateful to the following people who labored in the trenches to provide me with materials for this publication: Pauline Burton, Diane Holloway, Eloise Spears, Jackie and Michael Traeye, Lenora Massey Gary, Loretta Knight Wright, Genevieve M. Knight, Eugene Vallion Jr., Col. James H. Scott, Lola Jones Chappel, Annie Ruth Allen Stevens, Theophilus "Blain" Atkinson, Gerald Atkinson, Frankie and Doug Quimby, Albert Hose, Viola Abbott, Sophie Ramsey, Willie and Gloria Dean Simmons, Mr. and Mrs. Willie Moore, and Charles Easley.

This book is dedicated to my great grandparents Edward W. and Julia Sadler Wright and Raymond and Mary Isabel Rogers; my grandparents Annie C. and Benjamin J. Allen Sr. and Wesley and Gertrude Coker Rogers; my parents Benjamin J. Allen Jr. and Cauree E. Allen Dawson; my wife Helen; and Camara and Bakari, my children. It is also dedicated to my siblings—Catherine, Mildred, Lester, Robert, and Doretha—and to my grandchildren Damani and Donovan. All efforts expended here are for those who struggled in the kitchens, labored in the shrimp and crab factories, waited tables, and were overlooked on the streets as non-existent. This labor of love is dedicated to you, the pioneering African Americans who worked to improve this country and sought the American dream.

INTRODUCTION

This pictorial history depicts the African-American people of Glynn County, Georgia. Not only is it my own labor of love to record the significant contributions of small towns in America, but it is also the result of constant encouragement by Dr. Charles J. Elmore, professor of humanities at Savannah State University. For years I have held a keen interest in the accomplishments of African Americans from Glynn County, and over the years I have clipped articles and interesting artifacts with a possible book in mind. I knew Glynn County was outstanding when I discovered it was the birthplace of five former and one incumbent African-American college presidents. But what helped Rufus P. Perry, Cornelius V. Troup Sr., William H. Dennis Jr., Elias Bake, and Timothy Meyers achieve such a feat? I could not put it aside without further investigation.

After a 20-year absence, I returned to Brunswick and found that not only was I privileged to know African Americans from Glynn County, but that the entire nation was blessed by their presence on the American scene. I realized it would be devastating to leave the rich legacy of Glynn County's residents untold.

African Americans in Glynn County overcame adversity and inequality through education. The county's educational opportunities were enhanced by the establishment of two private high schools: St. Athanasius Episcopal School and Selden Normal and Industrial Institute. These institutions allowed Glynn County's African-American residents to become literate and excel as educators, doctors, lawyers, and entrepreneurs. Glynn County and its schools have produced an array of high-profile citizens such as Dr. Charles Wesley Buggs, renowned microbiologist listed in *American Men of Science*; his brother John Allen Buggs, former director of the U.S. Civil Rights Commission; Dr. Carl Ashley Dent, chemist; the infamous Nathaniel "Jim" Brown, actor and football great; and Robert Sengstacke Abbott, founder, editor, and publisher of the *Chicago Defender*. Also included are Whittier C. Atkinson, M.D., founder and director of the Clement Atkinson Memorial Hospital in Coatesville, Pennsylvania, and the highly praised Marilyn Moore Brown, who is rapidly emerging as one of today's versatile interpreters of opera, oratorio, and concert repertoire. She has performed as a featured soloist in venues such as Carnegie Hall, Lincoln Center, Philadelphia's Academy of Music, the Concert Hall, and the John F. Kennedy Center's Terrace Theatre.

The heroic pioneers of Glynn County gave inspiration to their distinguished descendants. Visitors to St. Simons Island Pier can find a park honoring Neptune Small, the personal slave of Capt. Henry Lord King of St. Simons Island. When Captain King was killed on the battlefield

in Fredericksburg, Virginia, Small bravely returned King's body to his home. Another significant event of heroism occurred when a group of Ebo tribesmen, frustrated by a miserable voyage and the devastating prospect of enslavement, defiantly drowned themselves in the Dunbar River at what is now called Ebo Landing.

Though a valiant attempt was made to involve as many people and collect as many resources as possible for this publication, there still may be enough unused materials to create a second volume. In any case, it is my hope that persons with access to information or photographs will continue to share their resources so that the rich heritage of Glynn County can be admired by all.

It is my hope that this one volume of Glynn County's African-American heritage will cultivate in each reader the same sense of pride I experienced while gathering the materials to illustrate our African-American neighbors' significant achievements. The faces and stories within these pages relate experiences that represent the tenacity necessary to foster a sense of courage in each new generation. Let this stand as a testament to those who struggled, labored, and persevered so that others could find equality in America.

"Emulation is the key to success: We stand because you stood before us."

One

PIONEERS

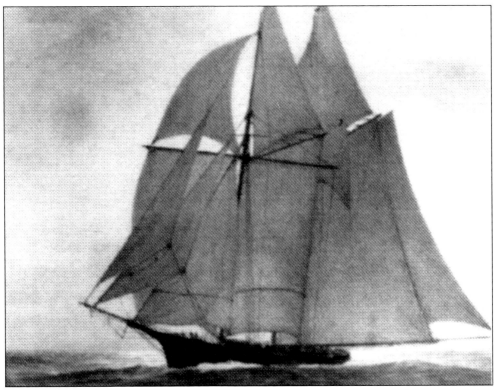

The *Wanderer* was built as a racing schooner in 1857 and became a slave ship in 1858 after being purchased by William Corrie of Charleston, South Carolina. In September of 1858, the *Wanderer* sailed to West Africa and returned in November to Jekyll Island with a cargo of 490 slaves, bought at the price of $600 each. The *Wanderer* was seized at the beginning of the Civil War by the Union Army and transformed into a warship. After the Civil War, the *Wanderer* was briefly used in the West Indian fruit trade before crashing against rocks and sinking at Cape Maisi, Cuba, in 1871. (Courtesy of *African American Heritage Highlights*, a brochure available from the Brunswick-Golden Isles Visitors Bureau.)

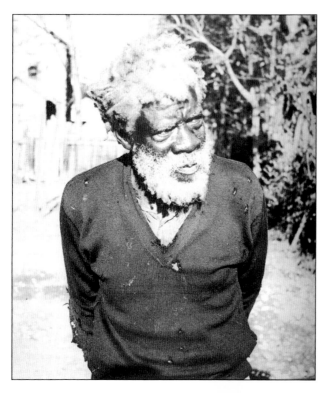

Dan Hopkins was born on Cumberland Island *c.* 1853. He was the property of Robert Church, and after the war he came to Brunswick where he lived with "Ole Missus" until she died. He then started as a deck-hand, finally working his way up to engineer on various steamers that made regular trips from Brunswick to Darien as well as to St. Simons, Jekyll, and Cumberland Islands. He worked on the *Egmont, City of Brunswick, Hessie, Attaquin, Emmeline*, and *Atlantic.* In 1882 he married Lena Carter of Sapelo Island. Dan and Lena lived in Brunswick and owned a comfortable home in Dixville. (Courtesy of *Early Days of Coastal Georgia.*)

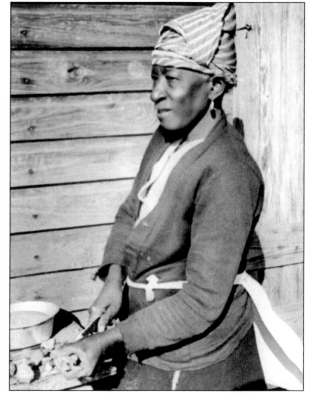

Edith Murphy was a St. Simons Island native whose ancestors belonged to the Demere family for many generations. Edith lived on the site where her ancestors were housed as slaves on what used to be Mulberry Grove. She was one of the group of singers who sang traditional spirituals and "shouts," her specialty being "Hush, Hush, Somebody Callin' My Name." (Courtesy of *Slave Songs of the Georgia Sea Islands.*)

Sibby Kelly was a midwife who lived in the African-American neighborhood known as Petersville, approximately 15 miles from Brunswick. It is believed she brought more babies into the world than any other white doctor who lived in Glynn County during her lifetime. When asked how many babies she birthed, she replied, "Didn't keep no count." When questioned about how many babies she lost, she responded, "Ain's los none, som ob'em die but tain' my fault." (Courtesy of *Early Days of Coastal Georgia*.)

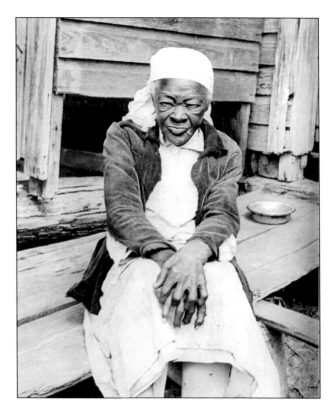

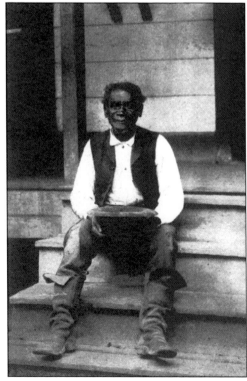

Oscar Massie was a life-long resident of St. Simons Island whose family was brought to the island for slavery. (Courtesy of *Early Days of Coastal Georgia*.)

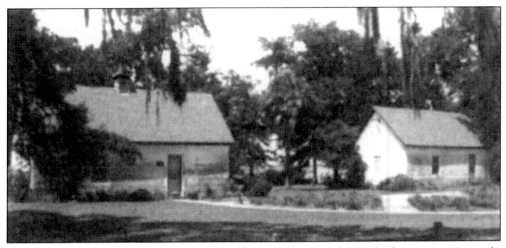

Pictured are two slave cabins (constructed of tabby) located at the Methodist Center, Epworth-by-the-Sea. Each building contained two rooms and an attic used for sleeping quarters, and a fireplace for cooking. (Courtesy of *Early Days of Coastal Georgia*.)

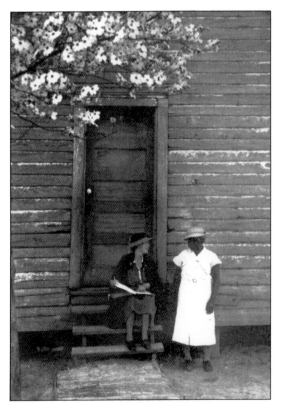

This is a picture of the two-room Harrington School, where many of St. Simons' African-American youngsters received their elementary education. Adrian and Louella Johnson tirelessly labored to ensure a quality education was given and received. Lydia Parrish, author of *Slave Songs of the Georgia Sea Islands*, is seen on the steps talking with Susyanna, one of the Sea Island singers. (Courtesy of *Slave Songs of the Georgia Sea Islands*.)

Ella Pinkney, whose life spanned more than a century, was born on St. Simons Island in 1852 and served as a house servant. Believed to have come from Senegal, she reflected on her age by remembering that she was a big girl waiting on Mr. Berrie's table when freedom came. (Courtesy of *Early Days of Coastal Georgia*.)

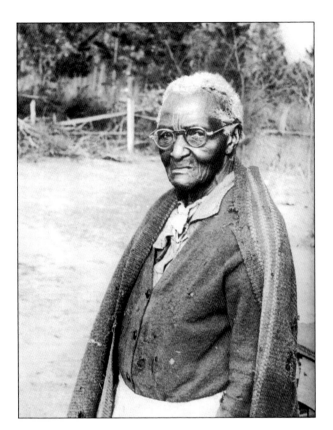

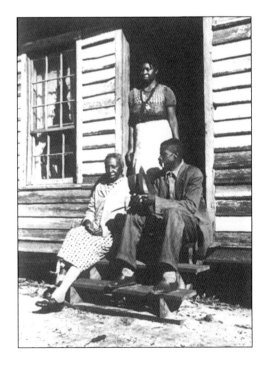

Ryna Johnson (left, seated), a former Couper slave, and family members sit on the front stoop of their home located in the Harrington section of St. Simons Island. Harrington was a section settled primarily by freed African-Americans after the war. (Courtesy of *Drums and Shadows*.)

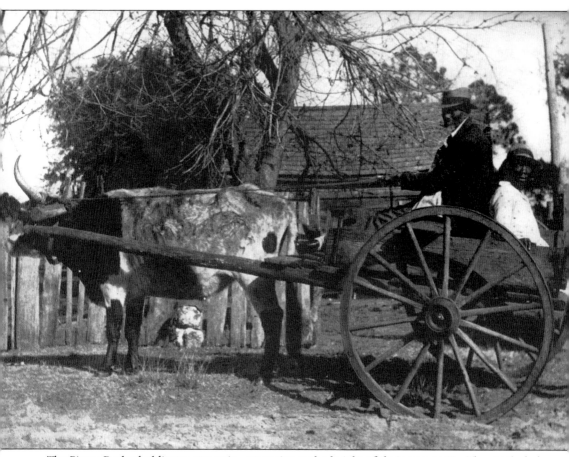

The Pierce Butler holdings were quite expansive at the height of their prosperity. They included Hampton (or Butler) Point, the Sea Island cotton plantation, the rice plantation on the delta of the Altamaha River, and Hammersmith, a tract on the mainland. At their peak these plantations were peopled with almost a thousand slaves. Liverpool Hazzard (pictured here) was the last of these. Born in 1828, Liverpool lived until 1938. During the Civil War, he was the cook for a company of Confederate soldiers commanded by Capt. William Miles Hazzard and stationed at Camp Walker, on the mainland in Glynn County. He often enjoyed telling stories about his experiences during that time. (Courtesy of *Early Days of Coastal Georgia*.)

Pictured here is Ben Sullivan. He is the grandson of "Old Tom," who was also known by his African name of Bilali or Sali-bul-Ali. Sullivan can trace his ancestry back to Old Tom's African homeland of Timbo, Guinea, West Africa. Following the emancipation of slaves, his family adopted Sullivan as their new surname. Relations native to Brunswick and St. Simons Island are Frank Sullivan (deceased), Frankie Sullivan Quimby, Pat Gary, Emery Rooks, Carolyn Rooks Whitfield, Samuel "Dent" Sullivan (deceased), Ephraim Sullivan (deceased), and Elizabeth Sullivan Jaudon (deceased). (Courtesy of *Early Days of Coastal Georgia*.)

Lavinia Sullivan Abbott is the sister of Ben Sullivan and a descendant of Old Tom, whose family was from the Foulah tribe. (Courtesy of *Early Days of Coastal Georgia*.)

15

Elizabeth Tyson Bryant was born at Buck Swamp. She is the grand-aunt of Lenora Massey Gary, the sister of Sallie Tyson Massey, and a relative of the Rooks, Tysons, and Masseys. (Courtesy of Lenora Massey Gary.)

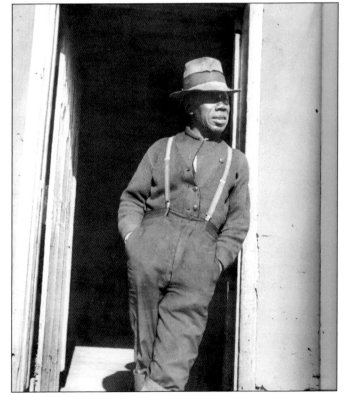

Floyd White was one of the last slaves to live in the old slave cabin on Retreat Plantation. His mother Victoria was a slave at Retreat, but his father Jupiter belonged to the Postells of Kelvin Grove Plantation. Floyd was also a member of the Sea Island singers and performed for audiences at the cabin and at the Cloister Hotel. (Courtesy of *Early Days of Coastal Georgia*.)

Sallie Tyson Massey was born at Buck Swamp and is the maternal grandmother of Lenora Massey Gary. She was related to the Tysons, Rooks, and Masseys. (Courtesy of Lenora Massey Gary.)

Pictured are the slave cabins of Hamilton Plantation, located on Gascoigne Bluff, which once belonged to James Hamilton. Hamilton came to America from Scotland with his friend John Cooper. The slave cabins were constructed of tabby, which is a mixture of sand, lime, seashells, and water that is hardened into a foundation. (Courtesy of *Early Days of Coastal Georgia*.)

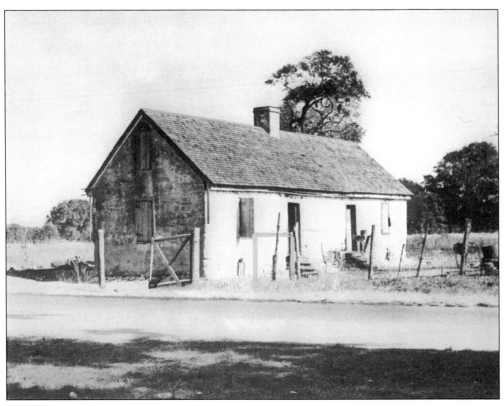

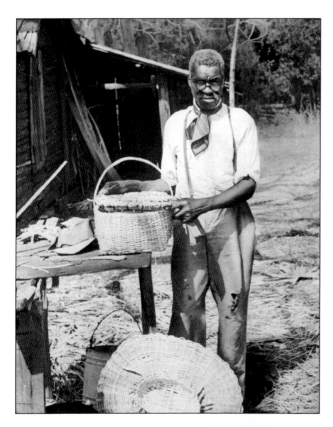

Charles Wilson did all his cooking outside because he feared an indoor fire would burn down his house. Placing some green wood or bricks across the top of his fire bucket, a frying pan would sit atop them to cook his hoe cake, which he said was as good as any bread cooked in a Dutch oven. (He also thought that potatoes roasted in the ashes were better than any other!) Wilson was also the last of the old basket makers to trade in the St. Simons area. His baskets were beautifully made with the leaf stem of the cabbage palmetto (or sabal palm), and no shoddy piece of work ever came from his hand. With a pocket knife, he would split these leaf stems and work them to a uniform width and thickness. Turning the outer surface of the stem to the outside gave the baskets a highly polished finish. (Courtesy of the *Early Days of Coastal Georgia*.)

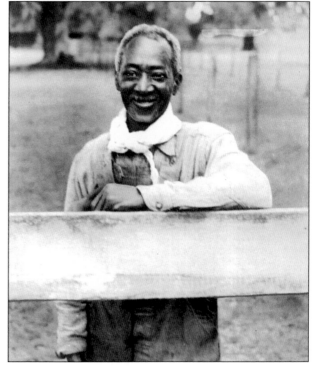

Morris Polite labored on Hofwyl Plantation from the time he was old enough to work until his death. Five generations of the Polite family worked on either the Hofwyl or Broadfield Plantations, and since the Civil War Morris, his grandfather, father, sons, and grandsons—five generations— have worked on this same plantation. He lived in Petersville, a settlement not any larger than two square miles. (Courtesy of the *Early Days of Coastal Georgia*.)

Robert Sengstacke Abbott, the pioneering newspaper publisher and editor, was born to former slaves in 1870 on St. Simons Island. He completed high school at the historic Beach Institute in Savannah, Georgia and studied printing at Hampton Institute between 1892 and 1896. In 1898, he received a law degree from Kent College of Law in Chicago, but was unable to practice because of his race. In 1905, he founded the *Chicago Defender*, America's first and most widely circulated African-American daily newspaper. In it, Abbott urged African Americans to move to the Midwest during the Great Migration around the time of World War I. Roi Ottley wrote his biography, *The Lonely Warrior: The Life and Times of Robert S. Abbott*. (Courtesy of the *Chicago Defender* Archives.)

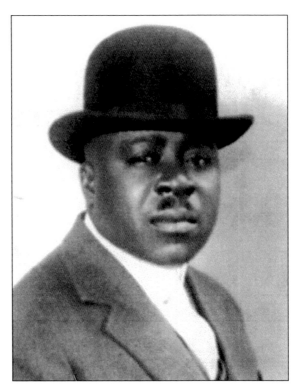

The wide success of the *Chicago Defender* helped St. Simons Island native Robert S. Abbott become one of the first self-made black millionaires in the country. He erected an obelisk in honor of his father Thomas Abbott (who was of a pure Ibo bloodline) and his aunts Gelia Abbott and Mary Abbott Finnick. (Courtesy of Abbott family members.)

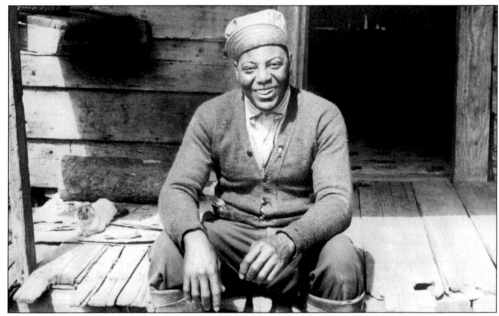

Jerry Harris's ancestors were a part of the Broadfield-Hofwyl Plantation, and lived in Petersville or what was commonly called "Needwood." Each of the families in this area could claim that as far back as anyone knows, all the generations of their family who lived in America have spent their lives in this small community. Mr. Harris always had a smile and was a man with a happy disposition, and his family displayed the same traits and joy for life. (Courtesy of *Early Days of Coastal Georgia*.)

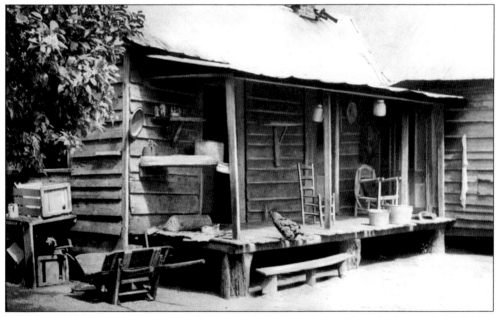

Jerry Harris's back porch, seen in the 1940s, displays a typical example of the houses built during this period. Most were constructed of wood with fireplaces used for heat during the winter. (Courtesy of *Early Days of Coastal Georgia*.)

Janey Jackson was born in 1826 at Kelvin Grove Plantation on St. Simons Island. She was sold with her parents to Henry duBignon of Jekyll Island. Her family remained in contact with friends and relatives on St. Simons and frequently rowed there from Jekyll. Janey became a Catholic and learned to speak French fluently. She never married, smoked a pipe, and cooked all her food outside in the yard. She was 109 years old when she died in 1936. (Courtesy of the *Early Days of Coastal Georgia*.)

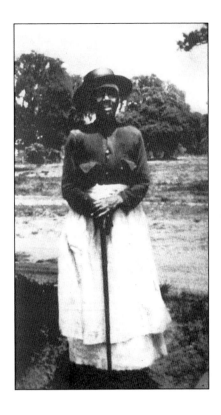

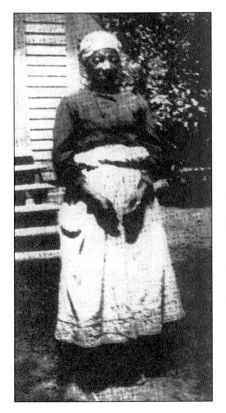

Considered a witch, Milly Polecat was a moody and peculiar character who was feared by other blacks. When her cabin was built, she insisted on having no windows—a traditional African style of construction. It is also said she would turn her back on someone when she had something to say. Milly was the wife of Jim Polecat (a name he purposely gave himself because of its uniqueness), a man who learned his craft as a "root doctor" in Africa and taught his wife how to make goof bags. Milly was also the mother of seven murderers: when Jim was old, decrepit, and considered a nuisance, his own children pushed him into the fireplace and burned him to ashes. (Courtesy of *Slave Songs of the Georgia Sea Islands*.)

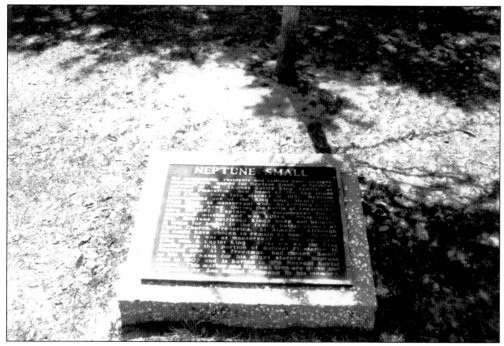

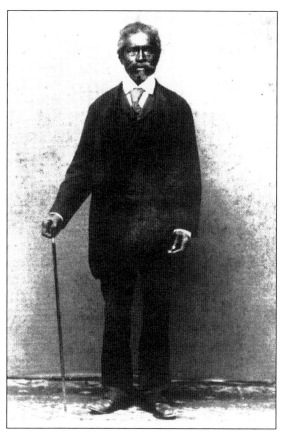

Located at Neptune Park on St. Simons Island, the Memorial Marker commemorates Neptune Small's service as a servant/slave to the Thomas King Butler family of Retreat Plantation. When Capt. Henry Lord Page King, son of the Thomas, enlisted in the Confederate, Neptune Small accompanied him to Virginia as his servant. Captain King was killed in Fredericksburg, Virginia, and his body was returned to St. Simons Island by Neptune himself. (Courtesy of Benjamin Allen.)

Neptune Small poses for a classic portrait, *c.* 1875. (Courtesy of the St. Simons Library.)

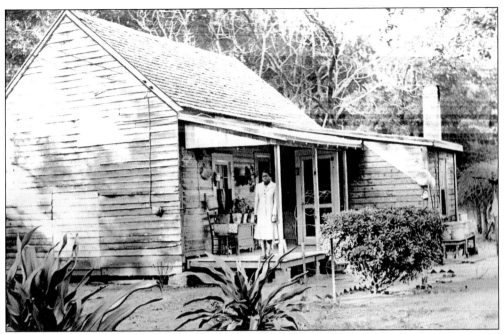

This house was the home of Neptune Small, servant of the Thomas Butler King family of Retreat Plantation. (Courtesy of *Early Days of Coastal Georgia*.)

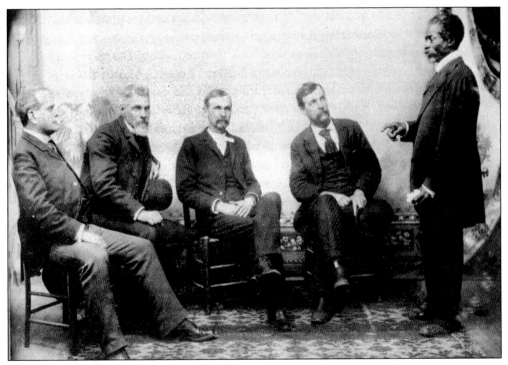

Gen. Floyd King, M.J. Colson, Jacob Dart, and Captain Wylly are shown listening to Neptune Small recount the events surrounding the battle of Fredericksburg, Virginia, where Capt. Thomas King Butler was killed, *c.* 1875. (Courtesy of the Sea Island Company.)

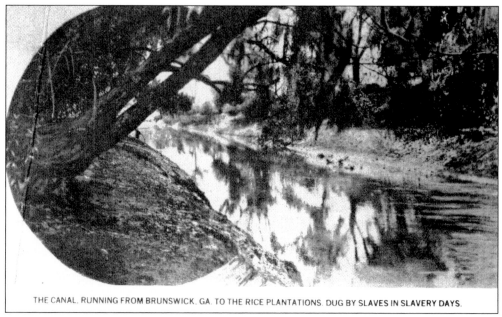

THE CANAL, RUNNING FROM BRUNSWICK, GA. TO THE RICE PLANTATIONS, DUG BY SLAVES IN SLAVERY DAYS.

This postcard depicts the canal that was dug by slaves from Brunswick to the rice plantations near Hofwyl, *c.* 1925. Thomas Butler King was instrumental in the instigation of this project. (Courtesy of Benjamin Allen.)

London Polite was the oldest son of Morris Polite, and he emulated his father's mannerisms, attitude, and disposition. London could always find a reason to laugh. His happy demeanor meant children liked nothing better than to be with him. London held charge of the Cate farm at Touchstone Ridge for 26 years; he also lived in Needwood near the Hofwyl plantation. Later he was drafted into World War I. (Courtesy of *Early Days of Coastal Georgia.*)

Georgia prohibited slavery from 1733 to 1749. Nevertheless, slaves were still smuggled in, and Ibo Landing on Dunbar Creek was an ideal place to them. Documentation in a letter at the Pennsylvania Historical Society (Philadelphia) confirms that a group of 10 to 12 Ibos brought from Nigeria, West Africa, revolted and drowned themselves at what is now called Ibo Landing. (Courtesy of *Early Days of Coastal Georgia*.)

This is William Mein's letter dated May 24, 1803 to Pierce Butler. A brief extraction of page one reads:

Dear Fr[?] Your esteemed favor of 2nd May we duely…[?] We have replyed to it in course of Port but his that we had been in treaty for was sold by her owners. They could not comply with the offer made you when in Savannah—this you may believe has distressed us not a little as we have not yet been able to procure you another. [?] we have wrote to Charleston as well as keeping a constant look out here. We had no idea that the political situation of Europe was likely to create such preference for our own [?] in freight or we would have put the matter beyond any doubt…

(Courtesy of the Historical Society of Pennsylvania.)

This is a brief extraction of page two of William Mein's letter dated May 24, 1803 to Pierce Butler:

> …as things now are we must do the best we can and accordingly have engaged the preference [?] of his coffered ship Cleopatra expected in a few days—she is a fine American vessel. By the time she arrives we shall certainly know whether England and France are serious about their intention of renewing the war—If peace is the order of the day we imagine you will prefer an English vessel as you formerly wished—and he must care [?] freight may be got at 1 [?]. If things are in the present doubtful state we may be obliged to give 2 [?] in an American Vessel but even this lost freight. We do not think [?] unreasonable good ship going around to your Plantation.

(Courtesy of the Historical Society of Pennsylvania.)

[handwritten manuscript reproduced above]

Here is yet another brief extraction of William Mein's letter to Pierce Butler, beginning with the last sentence of page two and moving on to page three:

[Mr. King advises his having got safe round with his Negroes...] that they are behaving well—we have had a great many Ibo and Angolas— all of which have readily sold about 100 pounds round for the [?]. Spaulding and Couper [bought?] a whole cargo of Ibos and may have suffered much by mismanagement of Mr Coupers overseer Patterson, who poor fellow lost his life. The Negroes rose by being confined in a small vessel. Patterson was frightened and in swimming ashore he with two sailors were drowned. The Negroes took to the marsh and may have lost at least ten or twelve in recovering them besides being subject to an expense of ten dollars a head for salvage—our friend Putman in his zeal for the service of the United States boarded the sloop your Negroes were [?]...

(Courtesy of the Historical Society of Pennsylvania.)

This is an extraction from page four of William Mein's letter to Pierce Butler:

...took [?] from Mr. King a Bond—for the consequences of showing it however to his Cousellor [?] they satisfied him that he had not only done wrong but...[?]...he was not authorized to touch the property or any person else unless he took them in his aid or had good proof of being importers[?]—so that we bona fide purchasers in the terra firma of the U.S. are at...[?]...as to...[?]... of the Law of Congress as well as that of the State of Georgia—We have got up his bond and transmitted same to Mr. King—we have just... [?]...accounts that a small vessel is daily looked for from the windward coast of Nassau and on her arrival Mr. King shall be presented with 100 prime fellows to pick and choose upon and we feel...

(Courtesy of the Historical Society of Pennsylvania.)

Naynie was the nanny for the King family and reigned supreme at Retreat. She took care of Ann Page King (seen here) when she was a baby and also helped to raise the third generation of Kings. (Courtesy of *Georgia's Land of the Golden Isles.*)

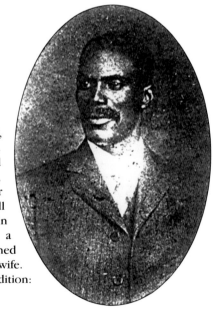

Jackson K. Sheffield of Everett City was born in 1858, the son of Jackson and Susan Armstrong Sheffield. Although denied a formal education, he learned well from his father (who was a farmer and carpenter), was very frugal, and worked for himself rafting timber down the river to Darien. The first turpentine still in Glynn County was set up on his property, and in 1906 he established a sawmill that operated with a capacity of 20,000 feet a day. At one point he owned more than 12,000 acres. Carrie Williams was his wife. (Courtesy of *History of the American Negro*, Georgia Edition: Volume I, 1917.)

Two

RELIGION

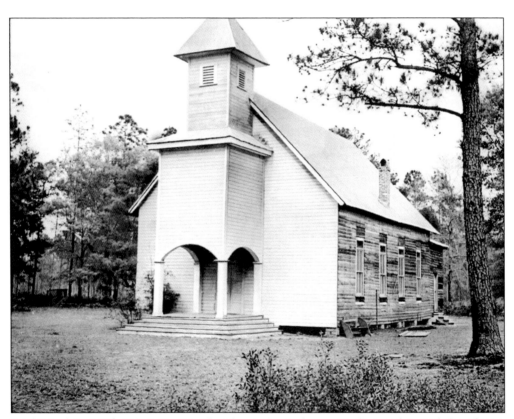

Established in 1874, Salem Baptist Church was located near Sterling and served the African-American population in that area of the country. Many were families of former slaves from the numerous plantations and rice fields nearby. The original members had previously worshipped at the Broadfield Baptist Church, and received a letter from these families to organize the new church; thus, Salem Baptist Church was formed. (Courtesy of *Early Days of Coastal Georgia*.)

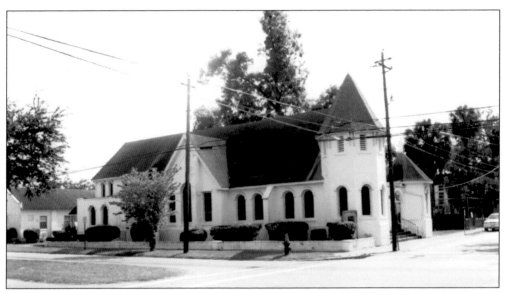

St. Athanasius Episcopal Church (pictured here) was established when Mary King Troupe and Louise Nightingale of St. Marks Church organized a Sunday school among the black people of Brunswick in 1883. The Rev. Henry Lucas began services in that same room on February 24, 1884. Rev. A.G.P. Dodge offered to build and furnish a church and a regular missionary, and in the latter part of June, 1885, St. Athanasius became an organized mission. In 1888 a parochial school was established under the direction of Dora White, and eventually grew to be a high school that even featured an industrial department. Dr. Scott Wood was the first black priest to be in charge of the mission. However, the trying days of post-War readjustment caused the school to close in 1928. Yet the church carried on, and currently is in its 117th year of serving its healthy and thriving congregation. (Courtesy of St. Athanasius Church Archives.)

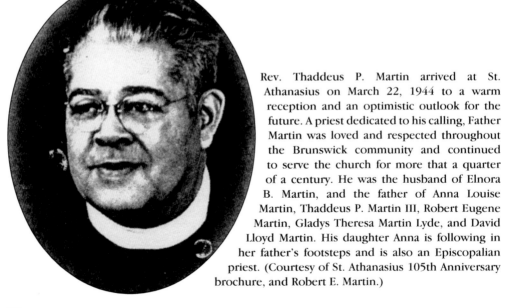

Rev. Thaddeus P. Martin arrived at St. Athanasius on March 22, 1944 to a warm reception and an optimistic outlook for the future. A priest dedicated to his calling, Father Martin was loved and respected throughout the Brunswick community and continued to serve the church for more that a quarter of a century. He was the husband of Elnora B. Martin, and the father of Anna Louise Martin, Thaddeus P. Martin III, Robert Eugene Martin, Gladys Theresa Martin Lyde, and David Lloyd Martin. His daughter Anna is following in her father's footsteps and is also an Episcopalian priest. (Courtesy of St. Athanasius 105th Anniversary brochure, and Robert E. Martin.)

Mt. Olive Baptist Church, located at "J" Street and Stonewall in Brunswick, was founded in 1890 with Rev. B.J. Green as the pastor. Reverend Rozell became the pastor in 1895 and served until 1957 when he retired because of ill health. The church has remained an active and vibrant part of the community for 112 years. (Courtesy of the Mt. Olive Baptist Church Archives.)

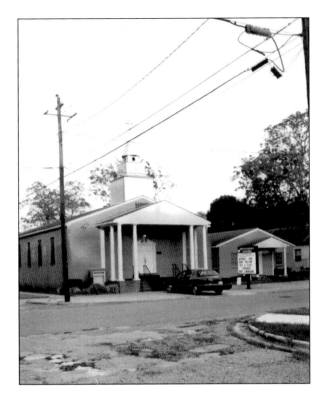

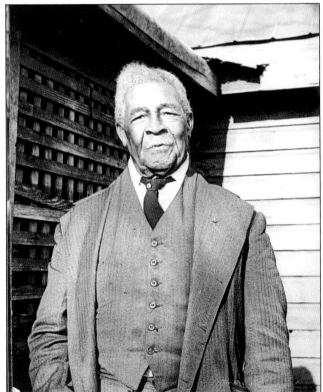

Rev. Elijah J. Rozzell served as pastor of Mt. Olive Baptist Church in Brunswick from 1895 to 1943. His arrival in Brunswick is an interesting one: Reverend Rozzell and his father arrived among 295 men, women, and children on February 23, 1893 from McCrory, Arkansas. They had come to Brunswick expecting to find a sailing ship waiting to take them to West Africa; however, a fraudulent "Back to Africa" scheme had clearly deceived them. (Courtesy of *Early Days of Coastal Georgia.*)

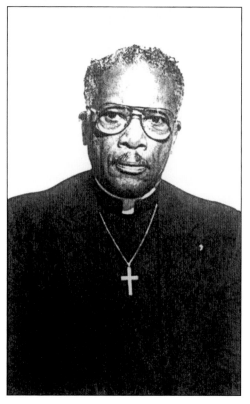

The First African Baptist Church of St. Simons was organized at White Bluff in 1859. Rev. Andrew Neal served as pastor for 28 years. Other officers were Prince Ramsey Sr., Wesley Lee Sr., July Hunter, Joe Abbott, Hilliard Johnson, A.B. Sullivan, Gabe Wilson, William Henry Murphy Sr., and Tobias Fahn. (Courtesy of First African Baptist Church Archives.)

Rev. E. Lewis Brogsdale, born in Brunswick in 1921, was educated at Colored Memorial and then Selden Normal and Industrial Institute. He served as pastor of St. Paul Baptist Church on St. Simons Island. (Courtesy of Selden Alumni Association program brochure, 1988.)

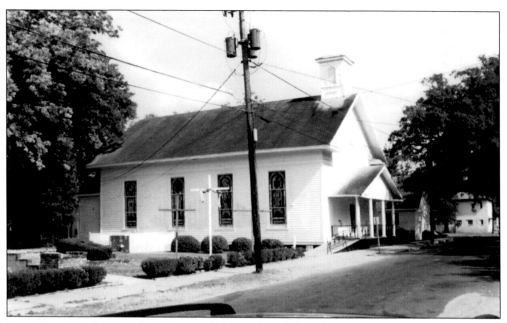

First African Baptist Church of Brunswick, located at 1416 Amherst Street, was organized in 1867. A generous white citizen named Urbanus Dart donated the land in 1869, and the present church still stands on that property. Rev. Frank Harrison, a missionary from Savannah, was the first minister. The church was also where the establishment of Selden Normal and Industrial Institute took place. (Courtesy of the First African Baptist Church Archives.)

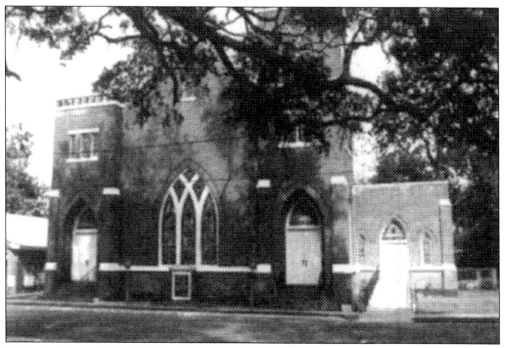

St. Paul's African Methodist Episcopal Church, located at 1520 Wolfe Street in Beaufort, is among the oldest African-American churches in the area.

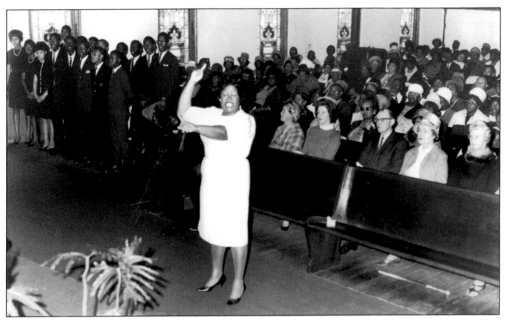

Race Relations Day was celebrated annually during the 1970s, and here Julia Ford Massey is shown directing the choir during a service at Shiloh Baptist Church. In the audience and the young standing choir are many members of the Brunswick community: John Beckham, June Tate, Bootsy Lewis, Ella H. Moore, Leo Moore Jr., Reginald Crittenden, Carl Brown, and Alice Mae Millian. (Courtesy of the Shiloh Baptist Church.)

Carlton Wesley Whitten, son of Mr. Danford and Mrs. Emma Taylor Whitten, was born 1912. He attended Risley School, and received his B.S. degree in Theology from Edward Waters College in Jacksonville, Florida. He was the pastor of the following churches: New Zion and Little Rock Baptist, Brunswick, Georgia; Tarboro Baptist, Tarboro, Georgia; St. Matthews Baptist, Folkston, Georgia; Mt. Pleasant Baptist, Callahan, Florida; and Peach Missionary Baptist, Jacksonville, Florida. (Courtesy of the Chapman and Whitten families.)

Eugene C. Tillman was minister of Shiloh Baptist Church. After serving two years in the U.S. Naval Reserve, he received a B.S. degree in psychology in 1948, and an M.Div. degree 1951. He has been active in community work most of his adult life; this includes co-founding the Glynn-Brunswick Ministerial Association and serving as the Human Resources Developer for the Coastal Area Planning and Development Commission (1969–1981). As director of the Comprehensive Area Wide Health Planning Programs, he assisted six counties with coordination of health care for citizens in southeast Georgia. Most recently he was selected as one of the 10 outstanding African-American ministers in Georgia. (Courtesy of *A Legacy Outstanding African-American Georgians*.)

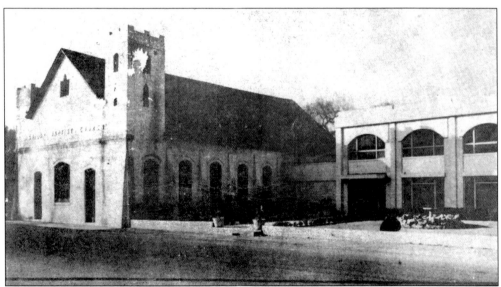

Shiloh Baptist Church was organized in 1873 and has served the residents of Brunswick well. Many Race Relations Day programs were carried out here, and it served as the launching pad for E.C. Tillman's bid for a congressional seat representing southeast Georgia. Shiloh has also been blessed with two ministers serving for more than 80 years: Fr. Stanton Roberts served for 50 years, and E.C. Tillman has served for more than 35. (Courtesy of the *Shiloh Baptist Church Anniversary Bulletin*.)

Emanuel Baptist Church (est. 1890) is a branch of the First African Baptist Church of Frederica. Thirty-one years after establishing the First African Baptist on the island, members from the south end were ready for a church closer to their homes. These people included Annie and Sonny Sheppard Sr.; Molly and Tobias Fahn Sr.; James and Jane Small; Phoebe and William Henry Murphy Sr.; Sandy and Marcia Anderson; and Adam Proctor. Fr. Andrew Neal served as the first minister. The original structure was by destroyed by the Tidal Wave of 1898. (Courtesy of Emanuel Baptist Church Archives.)

Elnora B. Martin, wife of Fr. Thaddeus P. Martin, is pictured here. (Courtesy of the *St. Athanasius 105th Anniversary Bulletin.*)

Three

EDUCATION

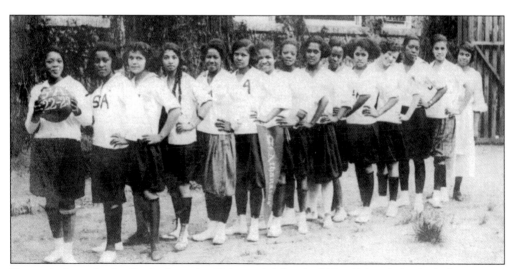

Pictured above is the St. Anthanasius Episcopal School 1922–1923 girls basketball team. St. Athanasius was a private high school organized to provide additional higher education when the city limited the education of blacks in Glynn County. Pat Gary of Colored Memorial's class of 1933 said that this was an excellent ball team. (Courtesy of Peggy Sullivan Hart.)

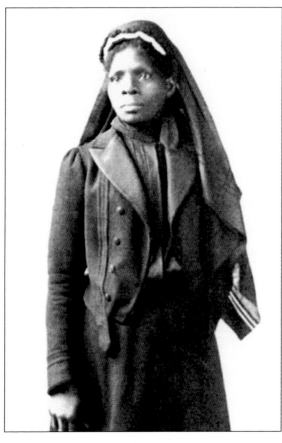

Susie King Taylor was born on August 6, 1848 at Isle of Wright in Liberty County, Georgia. She became St. Simons Island's first teacher after transferring to St. Simons Island from St. Catherine Island in May of 1862. Commodore Goldsborough asked her to take charge of a school for children on the island, where she taught 40 children and several adults at night.

Pictured is Selden Normal and Industrial Institute's class of 1903. (Class members are unidentified.)

Pictured is the cover of the *Short Story of the Life and Work of Miss Carrie E. Bemus.* Bemus was a white educational pioneer from Pennsylvania who organized Selden Normal and Industrial Institute in 1903, after having taught at Morehouse College in Atlanta, Georgia. (Courtesy of Ella B. Bohannon. Reprinted by Speedy Print, Brunswick, Georgia.)

SHORT STORY OF THE LIFE AND WORK OF
MISS CARRIE E. BEMUS

Miss Carrie E. Bemus,

Successful Teacher and Philanthropist, Found-
ed Selden Institute Oct. 6, '03, departed
this life June 9th, 1909.

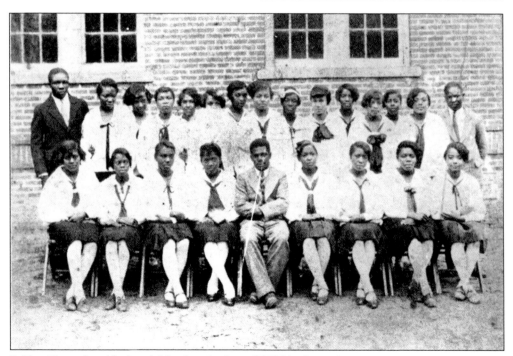

Selden Normal and Industrial Institute's class of 1928 is shown here.

Viola Elizabeth Burroughs was born 1894 in Brunswick to Richard and Virginia Walker Burroughs. She graduated from Selden Normal and Industrial School in 1914, and received her bachelor's degree from Georgia State Industrial College. Her graduate work was completed at Atlanta University and Tuskegee Institute, and she then taught for over fifty years in the Glynn County Public School System. Her name was honorably bestowed upon the Burroughs Molette Elementary School, located in the 2000 block of Lee Street. (Courtesy of Lenora Massey Gary.)

Sarah W. Molette was born 1885 in Atlanta, Georgia. She received her B.S. from Savannah State College and also did advanced studies at Hampton Institute in Hampton, Virginia. After more than 36 years of teaching, she retired in 1955. The class of 1957 found it a privilege to dedicate the school's first yearbook, *The Lighthouse*, to such a great and dynamic educator. (Courtesy of 1957 *Lighthouse Yearbook*.)

Cornelius V. Troop was born 1902 in Brunswick, and completed high school at St. Athanasius Episcopal School. He went on to receive an A.B. degree from Morris Brown College in 1925, a master's degree from Atlanta University in 1937, and a Ph.D. from Ohio State University in 1949. From 1945 to 1965, he served as the second president of Fort Valley State College, and was instrumental in helping it become Georgia's second African-American land-grant public college in 1949. (Courtesy of the Fort Valley State University Archives.)

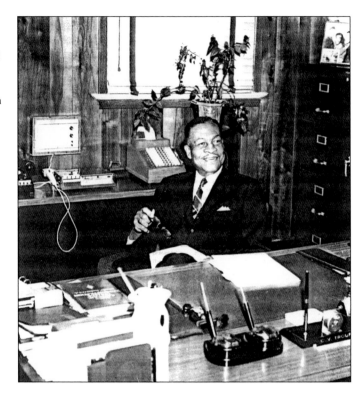

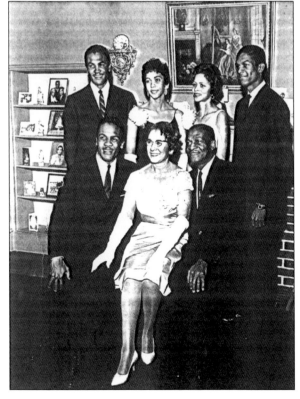

Seated from left to right are C.V. Troup Jr., Mrs. Katye Troup, and Dr. C.V. Troup Sr. Standing from left to right are Kenneth W. Troup, Mrs. Kenneth W. Troup, Mrs. Elliott Troup, and Dr. Elliott Troup. (Courtesy of the Fort Valley State College Archives.)

Elias Blake Jr., son of Elias and Ruth B. Blake, was born in Brunswick in 1929. Before becoming president of Clark Atlanta University (1977–1987), he graduated from Risley High School (1947), received his B.A. from Paine College (1951), his M.A. from Howard University (1954), and his Ph.D. from the University of Illinois (1960). He also holds an honorary LL.D. from Paine College (1983). Dr. Blake served in many civic roles. From 1967 to 1977, he affiliated with ISE, a non-profit research and development corporation, to facilitate greater access to higher education for blacks. He also served on the board of the Carnegie Foundation for the Advancement of Teaching. With his wife Mona Williams he fathered two children, Michael and Elias Ayinde. (Courtesy of *Who's Who in the South and Southwest.*)

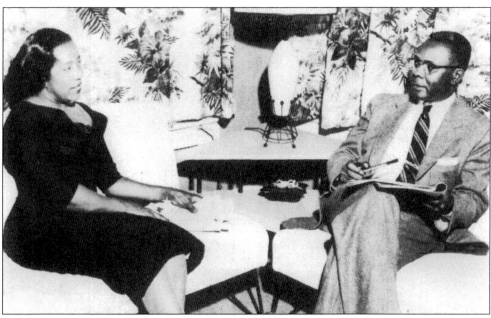

William H. Dennis Jr. was born in Brunswick to Rosalie Atwater and William H. Dennis Sr. He graduated from St. Athanasius Episcopal School in 1927, and received an A.B. from Morehouse College in 1931 and an A.M. from Atlanta University in 1942. He did further study at New York University and received his LL.D from Indiana University. Dr. Dennis was the director of student teaching at Morehouse and succeeded Dr. Brown as the third president in 1953, serving the institution for 11 more years until his death in 1965. During his tenure the College experienced enormous growth in its student enrollment and an upgrade of both its institutional programs and physical plant. (Courtesy of the *Distinguished Negro Georgians.*)

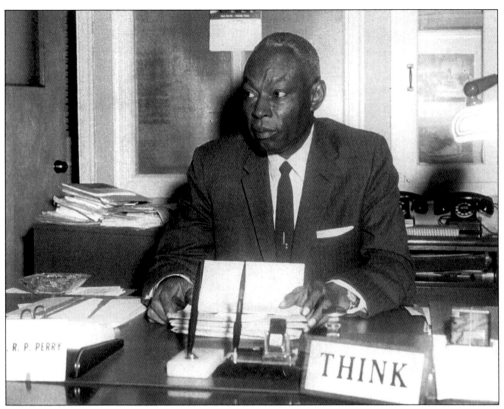

Pictured here is Rufus Patterson Perry, the eighth president of Johnson C. Smith University (1957–1968). He received his B.A. from Johnson C. Smith in 1925 and his M.S. and Ph.D from the University of Iowa in 1927 and 1939, respectively. Dr. Perry was active in many professional societies as well as in the Presbyterian Church. During his administration the university became fully accredited by the Southern Association of Colleges and Schools (SACS) for teacher education. He was the initiator of several construction projects, i.e. the new gymnasium, Smith Hall, and the college union building. While in office, enrollments increased and the faculty expanded by 18%. (Courtesy of Inez Moore Parker Archives & Research Center.)

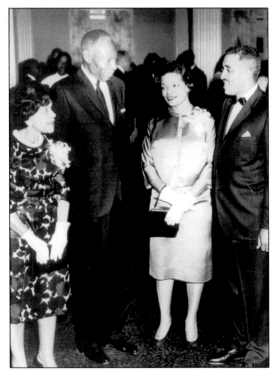

Dr. Rufus P. Perry and his wife Thelma (left) entertain Dr. and Mrs. Samuel Massey at a gala on the Johnson C. Smith campus. (Courtesy of the Johnson C. Smith Archives.)

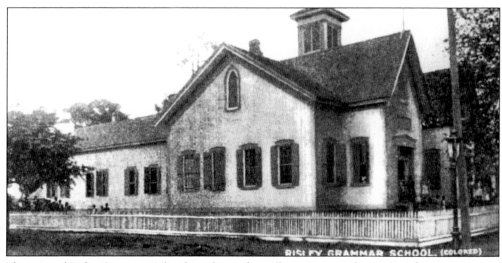

The original Risley Grammer School was located on Albany Street at the corner of "I" street. It was named after Douglas Gilbert Risley (1838–1882), who arrived in Glynn County in 1866 with the Bureau of Refugees, Freedman, and Abandoned Lands. (Courtesy of Richard and Gini Steele.)

J.S. Wilkerson was principal of Risley High School. He received his A.B. from Morris Brown College, and his M.Ed. from Atlanta University. (Courtesy of 1957 *Lighthouse Yearbook*.)

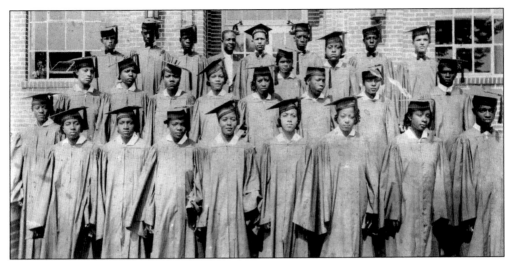

The first graduating class (1937) from the newly constructed Risley High School included, from left to right, the following: (front row) Katie Sullivan, Essie M. Wright, Eleanor Davis, Florence Guyler, Vivian Robinson, Eloise Harley, Georgia Walker, and Morris Wilson; (middle row) Georgia M. Floyd, Clyde Richardson, Dorothy Jordan, Annie R. Allen, Mildred Cuthbert, Trophine Wilson, Mary Miller, Lee Ellen Holmes, and Arthur Robinson; (back row) Roderick Holliday, Woodrow Kirby, Thomas Barr, C.V. Troup (principal), Charles Atkinson, Carolyn Philson, Moses Blaine, Mattie Dixon, Theodore Webber, and Samuel Dent. (Courtesy of Annie R. Allen Stevens.)

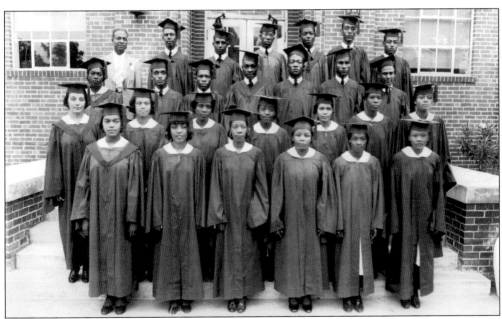

The Risley High School Class of 1939 included, from left to right, (front row) E. Cobb, S. Heidt, L. Anderson, unidentified, M. Mungin, and M. Signal; (second row) M. Caston, M. Armstrong, C. Lee, unidentified, H. Lewis, C. Reynolds, and P. Rhodes (Appling); (third row) C. Barnes, H. Smith, E. Brogsdale, W. Holmes, ? Jones, unidentified, and E. Lewis; (fourth row) C.V. Troup, O. Cobb (principal and later president of Fort Valley State College), H. Smith, J. Hall, C. Gibson, R. Kitchens, and H. Jackson (Courtesy of Creola Barnes Belton.)

Charles W. Buggs was born in Brunswick in 1906. He attended and graduated from St. Athanasius Episcopal School (1924), received his A.B. from Morehouse College (1928), and was awarded his M.S. and Ph.D. from the University of Minnesota (1932 and 1934, respectively). Dr. Buggs was an instructor at Dover State College, in Dover, Delaware; professor of chemistry at Bishop College in Tyler, Texas; professor of biology at Dillard University, in New Orleans; and instructor of medicine at Wayne State University in Detroit, Michigan. He was the co-author of numerous medical journal articles including 12 research studies on penicillin and skin grafting and was also listed in *American Men of Science* in 1943–1944. (Courtesy of *Who's Who in Colored America,* seventh edition.)

Ann Scarlett Cochran was born in Brunswick and was a high school graduate of St. Athanasius School. She received her A.B. from Howard University (1921), her M.A. from Columbia University, and pursued further graduate studies at University of Pennsylvania, Northwestern University, and the National University of Mexico. Ms. Cochran began her teaching career at St. Athanasius, and eventually taught at Morris Brown College, Savannah State College, Fort Valley State College, and Atlanta University. (Courtesy of *Who's Who in Colored America,* seventh edition.)

Priscilla Dennison Massey was born 1908 on St. Simons Island. She graduated from Selden Normal and Industrial Institute in 1928 and received a B.S. in education from Georgia State Industrial College in Savannah, Georgia. Massey would later become the first black female principal of Perry Elementary School, which was located on Stonewall Street in the 2300 block. This building now houses the bus yard and is the Adult Education Center. (Courtesy of Benjamin Allen.)

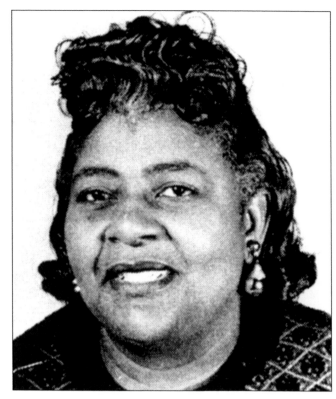

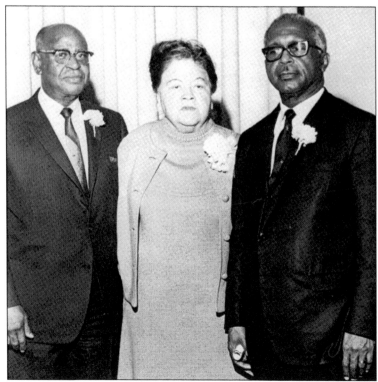

Ann Scarlett Cochran is pictured with Bishop E.L. Hickman (left) and Morris Brown President Dr. John Middleton (right), c. 1970. (Courtesy of *Morris Brown Yearbook*, 1970.)

49

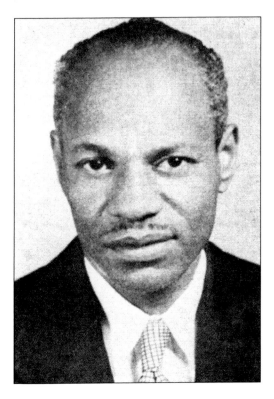

Richard H. "Bubba" Perry was born in Brunswick and graduated from Selden Normal & Industrial Institute. He then received an A.B. from Morris Brown College and did advanced work at Columbia University. As an instructor of mathematics and Hi-Y advisor, Perry was a caring and concerned teacher whose primary interest was each student's success—he would never accept mediocrity. (Courtesy of the 1957 *Lighthouse Yearbook*.)

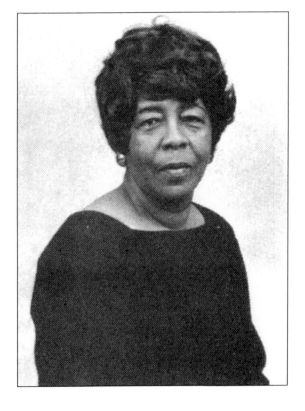

Birdie Palmer Williams, born 1910 in McIntosh County, graduated from Selden Normal and Industrial Institute and Savannah State College. Williams was a teacher in the Glynn County school system for over 30 years. She married to commissioner Thomas P. Williams, with whom she had one daughter. (Courtesy of Shiloh Baptist Church Bulletin.)

Clara Grant Lewis Childs was born 1924 in Brunswick, the daughter of James and Mamie Wright Grant. She graduated from Risley High School in 1942 and received a B.S. in education from Savannah State College in 1956. She married Ernest Lewis and had three children; later, she married James Childs. (Courtesy of Benjamin Allen.)

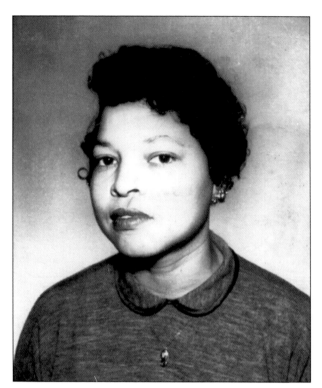

Betty J. Simmons Stuart Floyd, a Brunswick native and teacher at Risley High School, received a B.S. degree from Fort Valley State College. She was the daughter of Willie and Carrie Simmons. During high school, she was head majorette for the Risley High School Drum and Bugle Corps. (Courtesy of 1957 *Lighthouse Yearbook.*)

Carrie I. McIntyre Memorial
Gymnasium

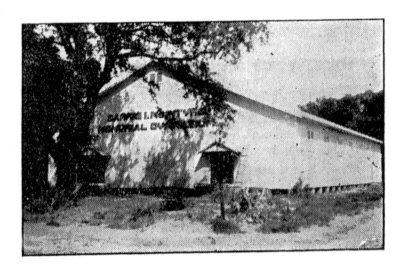

DEDICATED SUNDAY, OCTOBER 12, 1941
3:00 P. M.

SPONSORED BY
BRUNSWICK COUNCIL OF CIVIC CLUBS

OFFICERS:

J. P. ATKINSON, President

R. H. PERRY, Secretary

MRS. M. V. HARRINGTON, Assistant Secretary

H. E. DENT, Treasurer

Pictured is a copy of the original program cover printed for the dedication of the Carrie I. McIntyre Gymnasium, 1941. This structure was constructed by the students and faculty of Risley High School and was one of the finest gymnasiums in the Southeast, as well as among the first indoor facilities in the area. (Courtesy of Albert Hose.)

PROGRAM

J. P. Atkinson _____ Officer of The Day

J. S. WILKERSON _____ Master of Ceremonies

Praise God From Whom All Blessings Flow _____
 J. P. Atkinson, Presiding

Invocation _____ Rev. H. F. Brockington

Remarks _____ J. P. Atkinson

PROGRAM TURNED OVER TO MASTER OF CEREMONIES

God Bless America _____ Primary Grades
 Misses Atwater, Chandler, Denegal, and Dennis, Dir.

Remarks __ Mayor J. Hunter Hopkins, the City of Brunswick

Remarks _____ Commissioner R. A. Gould,
 The Glynn County Commissioners

Remarks _____ Superintendent R. E. Hood,
 Glynn County Board of Education

The Service of the Gym _____ Robert Youngblood

Quartette — Remember Now Thy Creator _____ Messrs. J. S.
 Wilkerson, S. C. Clements, E. V. Wright, C. V. Troup

Tribute to Miss McIntyre _____ Mrs. A. W. Holmes

Unveiling of Plaque _____ Howard Trimmings and Floyd Miller

Remarks _____ Mrs. G. V. Cate

Lift Every Voice and Sing _____ Audience

Introduction of Speaker by Prof. C. V. Troup, Registrar, Fort
 State College.

Dedicatory Address _____ William H. Shell,
 Negro Affairs Advisor, N. Y. A. for Georgia.

Music _____ Risley High Boy's Glee Club

Remarks - Announcements _____ J. P. Atkinson,
 Officer of the Day.

School Song _____ "Hail to Thee, Dear Old Risley"

Benediction _____ Rev. J. A. Edden

Pictured is the program's order of service for the gymnasium dedication. Note that many of the participants are listed in other places within this pictorial. (Courtesy of Albert Hose.)

Leon Lomax graduated with a B.S. from Fort Valley State College in Fort Valley, Georgia and an M.S. from Boston University in Boston, Massachusetts. He was the coach of the 1950 All-Conference Championship team with Edward Lowe, Jonathan Williams, B.J. Phillips, Milton Byard, and Snooks "Choo Choo" Jones. (Courtesy of 1957 *Lighthouse Yearbook.*)

Pictured is the 1956–1957 Risley High School basketball team. Standing from left to right are Leroy Edmonds, Henry Clark, Andrew King, Berrien Gibson, Ernest Bell, William Arnett, L.D. Blue, Virgil Ryals, John Davis, Freddie Alford, John Cherry, James Stokes, and Raymond Williams; Eddie Harrington is kneeling in the front. (Courtesy of 1957 *Lighthouse Yearbook.*)

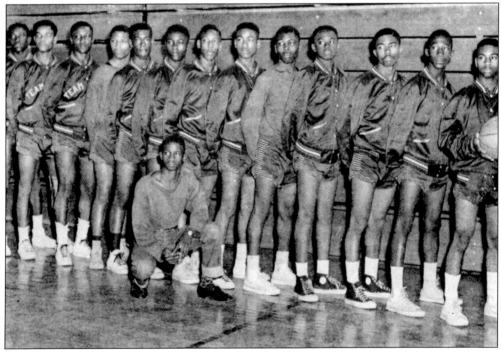

Walter C. McNeely graduated with a B.S. from Fort Valley State College (1949) and an M.S. from New York University. After J.S. Wilkerson's retirement, he became principal of Risley High School. He served in this capacity until he was appointed as the first black assistant superintendent of Glynn County schools and was later appointed as interim school superintendent for Glynn County. (Courtesy of Glynn County Board of Education.)

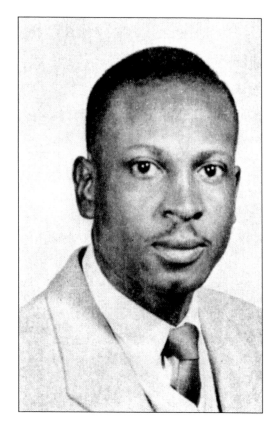

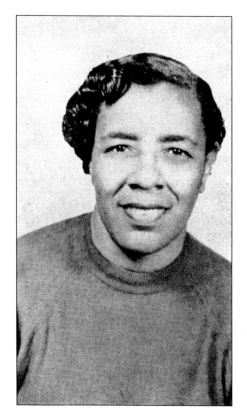

Eunice F. Minor, a native of Brunswick, was one of five children of Judson and Enos Minor, and sister of Julia Minor Life. She received her B.S. degree from Chaney State Teacher's College in Pennsylvania, and served in the Women's Army Corps (WACS) during World War II. She taught social studies and mathematics in the Glynn County public school system until her retirement. (Courtesy of 1957 *Lighthouse Yearbook.*)

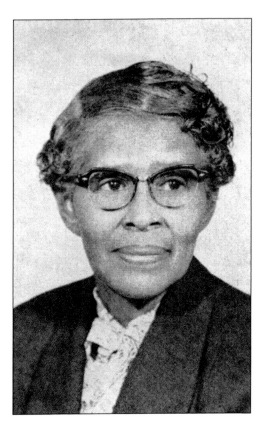

L.E. Cameron received her teaching certificate from State Teachers College in Cheyney, Pennsylvania, and studied further at Tuskegee Institute in Tuskegee, Alabama. Ms. Cameron was an English teacher and was the last of a dying breed of women in Glynn County who dedicated their lives to teaching. (Courtesy of 1957 *Lighthouse Yearbook*.)

Alice J. Collins, a teacher at Risley High School, received her B.A. from Paine College in Augusta, Georgia. She was the owner of Collins Funeral Homes, and a member of St. Andrews Methodist Church. (Courtesy of 1957 *Lighthouse Yearbook*.)

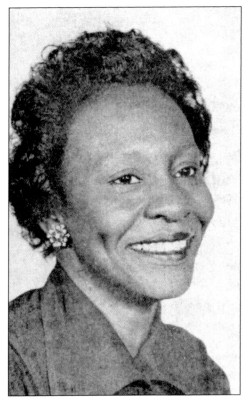

Mariah Claudette Abbott was born on St. Simons Island in 1929 to Malcolm and Mildred Abbott. She attended and completed Harrington Grade School, Gillespie Selden Institute High School, Barber Scotia College, Hunter College, and City College of New York. She was an educator in the New York City School system, and attained the position of assistant principal during her 45-year tenure.

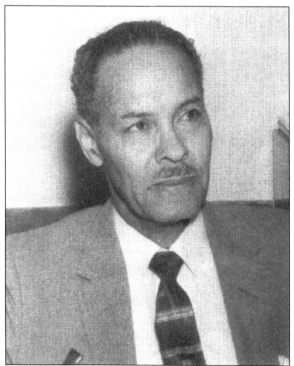

Timothy C. Meyers, BA, MA, was born in Glynn County at Brookman; he was dean of faculty at Savannah State College and served for a short period in 1949 as interim president of the college. His tenure as dean continued for 30 years.

Adrian H. Johnson was born on St. Simons Island, the son of Mrs. Jenny Holmes. He attended St. Athanasius in Brunswick, and received his A.B. at Claflin College in Orangeburg, South Carolina. Johnson and his wife Louella initially taught at the two-room school at Harrington on St. Simons Island. When the school closed, they were reassigned to teach in the Brunswick public school system. (Courtesy of 1957 *Lighthouse Yearbook.*)

R.E. Badger, an English teacher at Risley High School, received her B.S. from Savannah State College in Savannah, Georgia. (Courtesy of 1957 *Lighthouse Yearbook.*)

Genevieve M. Knight was born in Brunswick in 1939, and was the Risley High School class of 1957 valedictorian. She received a B.S. from Fort Valley State College in 1961, an M.S. from Atlanta University in 1963, and a Ph.D. from the University of Maryland in 1970. She taught at Hampton Institute (now University) and is currently at Coppin State College. She won distinguished teaching awards from both Hampton (1976) and Coppin State (1990). In 1980 she was named Virginia College Mathematics Teacher of the Year, and in 1993 Maryland College Mathematics Teacher of the Year. As a mentor, she was honored in 1987 with the Outstanding Faculty Award for Mathematics and Mentoring of Minority Youth from the White House Initiative on Historically Black Colleges and Universities. She was named Wilson H. Elkins Distinguished Professor for the University system of Maryland in 1996. (Courtesy of Genevieve M. Knight.)

Barbara Joyce Hill Floyd, the daughter of Mr. Earl and Matilda (Tillie) Denegal Hill, was born in 1935 in Glynn County. She was reared on St. Simons and Jekyll Islands, Georgia. A 1953 graduate of Risley High School, she attended Clark College in Atlanta, Georgia and graduated with a B.S. from Tennessee State University in Nashville, Tennessee. Mrs. Floyd taught in both Camden and Glynn County school systems and retired after 30 years of service. However, Ms. Floyd remained an active member of the community. She became the GED Test Administrator at Glynn County Adult Education Center and a member of AKA Sorority, Inc.; she co-organized the Southeastern and the Earl Hill Golf Tournaments; organized the Fairway Ladies Golf Auxiliary; and coordinated the "Miss Southeastern" pageants for several years. (Courtesy of Gerri Chapman Culbreath.)

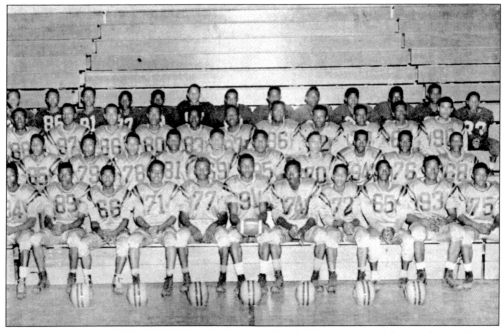

Pictured here is the 1956–1957 Risley High School football team. Seated from left to right are (first row) Edward Jones, Edward Parker, Roosevelt Lawrence, Buddy Hooper, John Davis, Andrew King, Othella Speakman, Philmon Hunter, Eddie Harrington, Paul Nelson, and Leo Williams; (second row) William Hunter, Robert Alford, Harry Murray, Zack Lyde, Virgil Ryals, Amos Jackson, Jamie Parham, Abraham Smith, unidentified, and Jerome Vickers; (third row) Ernest Bell, unidentified, Henry Jackson, unidentified, Eugene Edmonds, Samuel Scott, James Baker, Alex Speakman, Raymond Ramsey, unidentified, and Donald Brown; (fourth row) Joseph Murray, Kenneth Livingston, Charlie Walker, unidentified, Arthur Haugabook, Robert Grant, Raymond Proctor, unidentified, Roosevelt Cross, and four unidentified men. (Courtesy of 1957 *Lighthouse Yearbook.*)

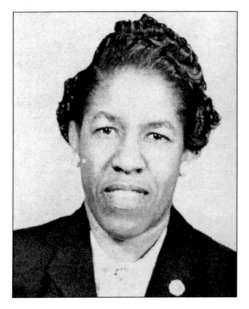

Edith Ella Hopkins Moore was born in 1914 at Fancy Bluff. Receiving her early education at St. Athanasius Episcopal School, she eventually graduated from Glynn County Public Schools, attended Morris Brown College, graduated with a B.S. in elementary education from Savannah State College, and received her M.S. from Tuskegee Institute. Moore was the first black tennis champion of Brunswick and taught in Glynn County Public Schools for 41 years. She was united in marriage to Leo Moore Sr. and was the mother of one son, Leo Moore Jr. (Courtesy of Lenora Massey Gary.)

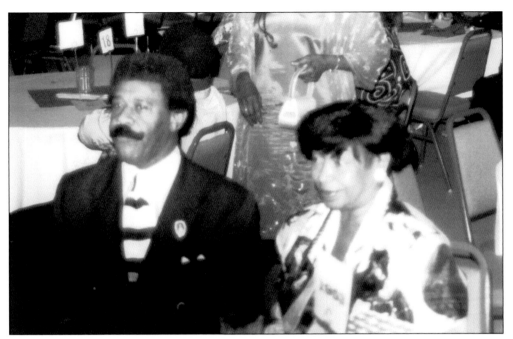

David Blount, a native of Glynn County, and his wife attend a banquet for Risley High School's all-class reunion at Jekyll Island Convention Center in the 1980s. Blount received his graduate and Ph.D. degrees from Georgia State University in Atlanta. (Courtesy of Benjamin Allen.)

Elaine Cash Mainor, born in Brunswick, graduated from Risley High School and is a high school mathematics teacher at Brunswick High School. She is the daughter of Katie Cash, and a graduate of Selden Normal and Industrial Institute. (Courtesy of the *Brunswick High School Yearbook*.)

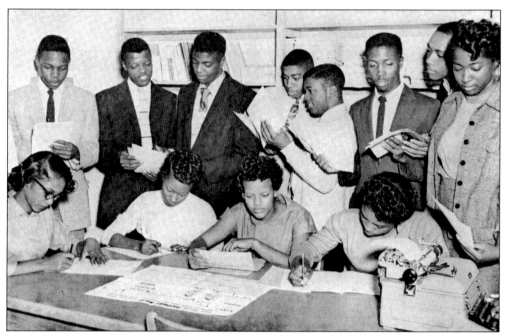

The Risley High School class of 1957 *Lighthouse Yearbook* staff includes (seated) Betty Daniels, Velma Stephens Crosby, Cynthia Allen, and Juanita Paris; (standing) Clarence Daniel, Lee Baisden, James Baker, James Morman, Charlie Taylor, Robert Bethel, Benjamin Allen, and Genevieve Knight. This class project became the first yearbook published at Risley High School. (Courtesy of 1957 *Lighthouse Yearbook*.)

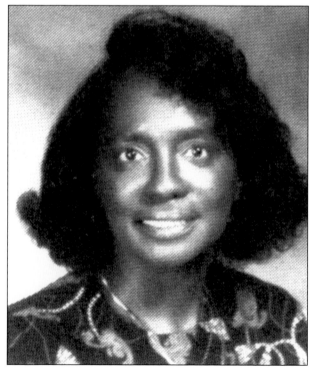

Nellie Pinckney, wife of the late Edward Pinckney, was a high school home arts teacher at Brunswick High School. (Courtesy of the *Brunswick High School Yearbook*.)

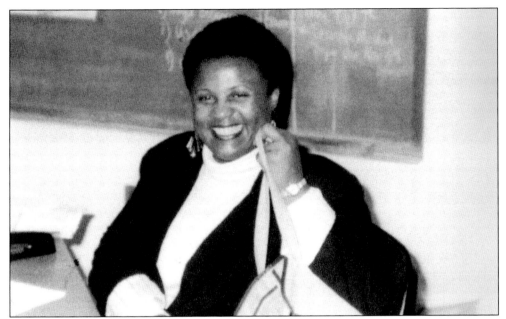

Erlene Lyde was born in Brunswick, the daughter of Zack and Lydia Lyde. Erlene is a high school chemistry teacher at Brunswick High School. She received both her B.S. and M.S. degrees from Duke University in North Carolina. (Courtesy of the *Brunswick High School Yearbook*.)

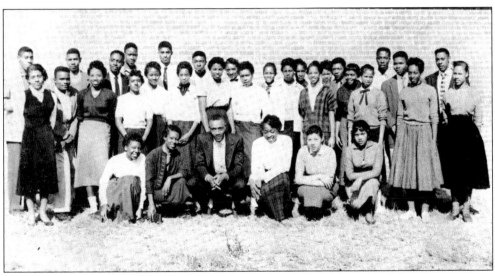

This picture show "Le Cercle Francais"—the French Club at Risley High School. Shown from left to right are (kneeling) Eloise Robinson, Velma Stephens Crosby, Benjamin Allen, Genevieve Knight, Judith Wilson, and Inez Coleman; (standing, first row) Mrs. JoAnn Ferguson Boone, Nathaniel Green, Juanita Paris, Yvonne Calhoun, Johnnie Carter, Juanita Peterson, Juanita Hall, Elizabeth Bryant, unidentified, Elizabeth Jaudon, Elouise Stevens, Muriel Williams, Caroline Rooks, and Claretha Sanders; (back row) James Morman, Bennie Bowden, Willie Lampkin, Paul Nelson, Donald Brown, Joseph Jaudon, Roberta Caine, unidentified, Evelyn Robbins, Pearlie Mercer, Archie Ponder, Robert Bethel, Lawrence Hutcherson, and Robert Peterson. (Courtesy of 1957 *Lighthouse Yearbook*.)

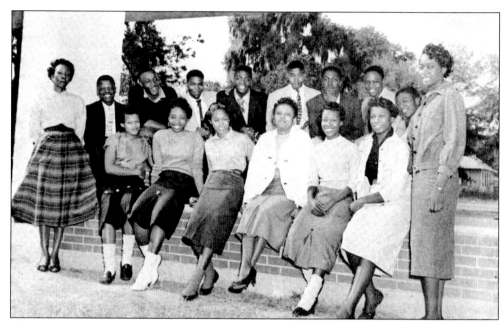

The Risley High School class of 1957 *Lighthouse Yearbook* staff is shown during a period of rest. Seated, from left to right, are Cynthia Allen, Juanita Paris, Betty Daniels, Mrs. Ruth (Lovelace) Williams, Velma Stephens Crosby, and Juanita Hall; (standing) Mrs. Alice J. Collins, Lee Baisden, Benjamin Allen, Lawrence Hutcherson, James Baker, James Morman, Robert Bethel, Clarence Daniel, Charlie Taylor, and Genevieve Knight. (Courtesy of 1957 *Lighthouse Yearbook.*)

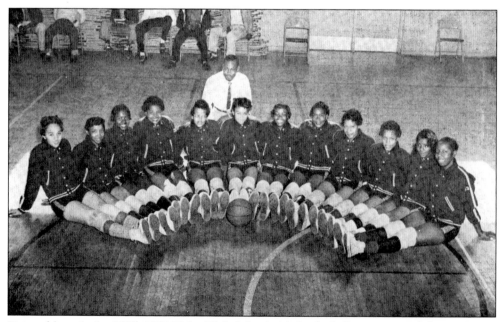

Pictured here is the 1956–1957 Risley High School girls basketball team. From left to right are Coretha Pyles, Marilyn Young, Delores Alford, Sally McGirth, Cynthia Allen, Lynette Tyson, Elouise Stevens, Roberta Caine, Pearlie M. Mercer, Roxie Brantley, Hazel Bess, and Pearl Houston. Coach Walter McNeely is kneeling in the rear. (Courtesy of 1957 *Lighthouse Yearbook.*)

Eunice Hazelhurst Hamilton was born 1928 in Brunswick to Jim Hazelhurst and Hattie Mae Johnson Hazelhurst. A 1946 Risley High School graduate, Hamilton attended Tuskeegee Institute in Alabama. She received her B.S. degree from Delaware State College in Dover, Delaware, and taught school in that state until her retirement. In 1991 she received the Outstanding Teacher Award for the Brandywine School District. Upon retiring, she returned to Brunswick to live out her remaining years. (Courtesy of Geri Chapman Culbreath.)

Gwendolyn E. Knight, a Brunswick native and eldest daughter of Thomas C. and Ruth Knight, received her B.S. degree (with honors) from Fort Valley State College in Fort Valley, Georgia, and a master's degree in mathematics from Florida A&M University. She taught in the Glynn County public school system for several years before becoming a mathematics professor at Florida A&M. (Courtesy of 1957 *Lighthouse Yearbook*.)

Ruth Polk Lovelace Williams was born in Brunswick, received her A.B. from Spelman College, and engaged in further study at Atlanta University. She is an instructor of social science and taught at Risley High School. (Courtesy of the *1957 Lighthouse Yearbook.*)

Herbert R. Pinkney was born in Brunswick and graduated from Selden Normal and Industrial Institute. He continued on to eventually earn his Ph.D. (Courtesy of Selden Normal and Industrial Institute.)

Jo Ann Ferguson Boone received her A.B. from Johnson C. Smith University in Charlotte, North Carolina. She was an instructor of English, French, and world history. (Courtesy of 1957 *Lighthouse Yearbook*.)

M. Delores Livingston was born in Brunswick and graduated from Risley High School. She received her B.S. at Albany State College and conducted further study at Boston University in Boston, Massachusetts. She was an instructor of language arts, social studies, and science. (Courtesy of the 1957 *Lighthouse Yearbook*.)

E. Florine Wilson held a B.A. from Knoxville College in Knoxville, Tennessee. She did advanced studies at New York University in New York City. (Courtesy of the 1957 *Lighthouse Yearbook*.)

A native of Brunswick, Doris L. Johnson received her A.B. degree from Clark College in Atlanta, Georgia and went on to study further at South Carolina State College in Orangeburg. She was an instructor of English. (Courtesy of the 1957 *Lighthouse Yearbook*.)

Edward F. Parrish Jr. was born in Augusta, Georgia. He received his B.S. from North Carolina A&T and his M.S. from Bradley University in Peoria, Illinois. He taught industrial education and algebra. (Courtesy of the 1957 *Lighthouse Yearbook*.)

C.J. Coleman received her B.S. at Fort Valley State College and went on to study at Atlanta University. She was an instructor of language arts, history, and science. (Courtesy of 1957 *Lighthouse Yearbook*.)

Jonathan Williams was born on St. Simons Island and graduated from Risley High School in 1951. After receiving his B.S. from Bethune Cookman College, Williams was coach of Brunswick High School, assistant principal of Jane Macon Middle School, and principal of Risley Alternative High School. (Courtesy of the 1988 *Jane Macon Middle School Yearbook*.)

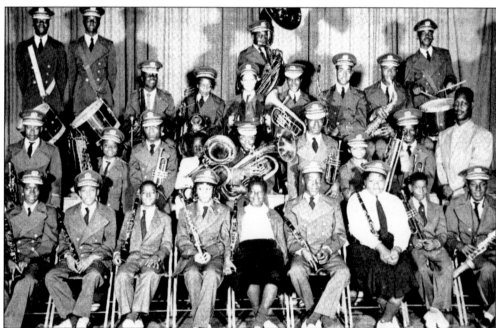

Pictured here is the Risley High School Band. From left to right are (front row) three unidentified boys, Mildred Hayes, Tilly Gilliam, Joseph Norman, Freddie M. Grant, unidentified, and Leonard Ratliff; (second row) Leo Moore Jr., Marva Hardee, Archie Ponder, George Jackson, Edna Gilliam, unidentified, Marion Jaudan, and unidentified; (third row) Edward Council, John Polite, Damon Council, Mary Culbreath, Anna Martin, Evelyn Robbins, Henry Jackson, B. Allen, and unidentified. (Courtesy of 1957 *Lighthouse Yearbook*.)

Willie L. Atkinson Buggs was born in
Brunswick to Clement and Mary Miller
Atkinson. Before she became a teacher at
Risley High School, she received her A.B. from
Morris Brown College in Atlanta, Georgia.
(Courtesy of 1957 *Lighthouse Yearbook.*)

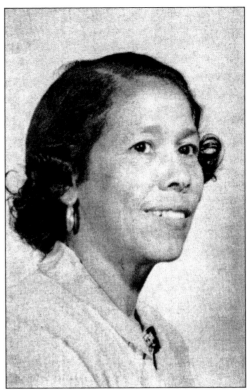

Walter C. Belton served as principal of Risley
Middle School, and also taught algebra and
history. He received a B.S. from Bluefield
State College in West Virginia, and an M.S.
from New York University. He married Creola
Barnes Belton of St. Simons Island. (Courtesy
of 1957 *Lighthouse Yearbook.*)

71

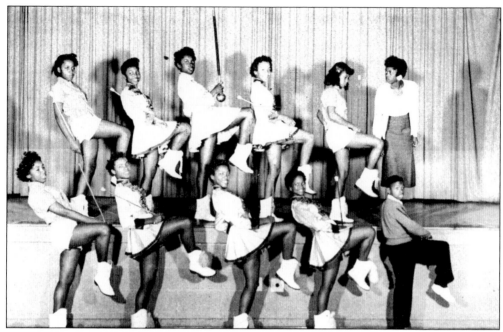

Pictured here are Risley High School majorettes in 1957. In the front row, from left to right, are Patricia Jaudon, Leola Hopkins, Roxie Brantley, Muriel Williams, and Leon Day; in the back row are Betty Jo Higginbottom, Ella Chapman, Carlee Barnaman, Hobbs, unidentified, and Betty Floyd. (Courtesy of the 1957 *Lighthouse Yearbook*.)

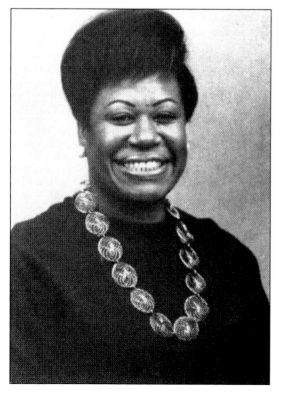

Julia Massey directed the Glynn Academy High Choir during the Race Relations Day Service at Shiloh Baptist Church in 1972. Ms. Massey was instrumental to the career of the internationally known soprano Marilyn Moore Brown. (Courtesy of Shiloh Baptist Church Archives.)

Dr. Tommie E. McCloud, teacher of social studies and band director, was born in Brunswick and graduated from Risley High School. He received a B.S. from Fort Valley State College and a Ph.D. in clinical psychology from the University of Michigan. McCloud was also an excellent jazz reed and woodwind player. (Courtesy of the 1957 *Lighthouse Yearbook.*)

Willie C. Bowden, teacher of industrial arts at Risley High School, received his B.S. from Savannah State College. (Courtesy of 1957 *Lighthouse Yearbook.*)

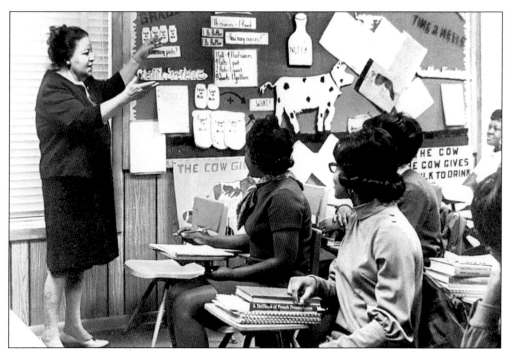

Dr. Ann Scarlett Cochran is seen teaching an education class at Morris Brown College c. 1970. Dr. Cochran taught as a visiting professor during summers at Fort Valley State College, Savannah State College, Clark College, and Atlanta University. She was born in Brunswick in 1899. (Courtesy of *Distinguished Negro Georgians*.)

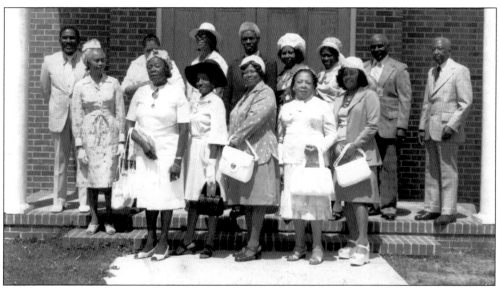

This is a picture of the Colored Memorial class of 1933 reunion. Shown from left to right are (front row) Carrie Harris, Marie Bryant Logan, Jenny Flanders, Mabel Taylor, and Willie Ryals; (back row) Jasper Barnes, Edwina Blake, Candice Barnes, Carrie Simmons, Lang Bens, Ruby Knight, Emma Lowe, unidentified, and Thomas Scott. John A. Buggs, the U.S. Commissioner on Civil Rights, was a member of this class. (Courtesy of Lenora Massey Gary.)

Louise Rhaney was born in Brunswick to Isacc and Louise Williams. She is a special education teacher at Brunswick High School. (Courtesy of the *Brunswick High School Yearbook*.)

Dr. Harrison H. Cain, graduate of Selden Normal and Industrial Institute, earned a Ph.D. and became the first president of the Selden Alumni Association in 1910. He was also a teacher. (Courtesy of the Selden Alumni Association.)

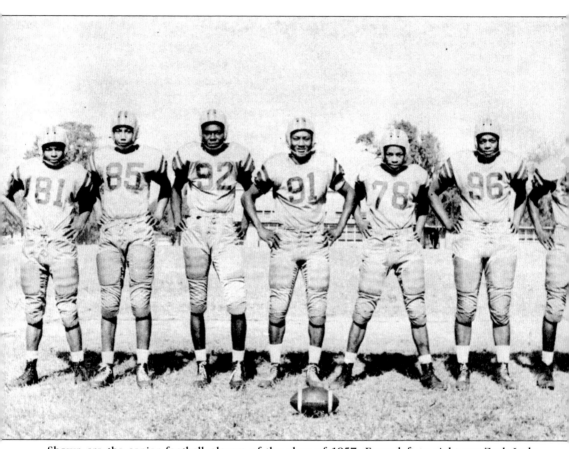

Shown are the senior football players of the class of 1957. From left to right are Zack Lyde, William Hunter, Roosevelt Williams, Andrew King, Harry Murray, James Baker, and Abraham Smith. (Courtesy of the 1957 *Lighthouse Yearbook*.)

Four

ARTS AND ENTERTAINMENT

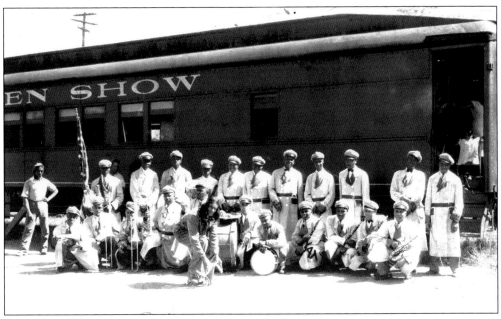

The Silas Green Band is pictured in front of its private rail car in Brunswick, Georgia. Kneeling fourth from the right is band member Nathan R. Belvin, and kneeling fourth from the left is bandleader Edward "Eddie" Washington, a Savannah, Georgia native. In the late 1800s, circuses, large tent shows with bands, vaudeville shows, and minstrels traveled throughout the United States. The Silas Green Band and Review was one of these and played in Southern cities until the 1950s. (Courtesy of Lola Jones Chappel.)

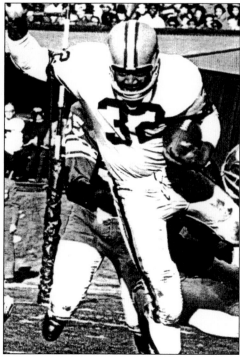

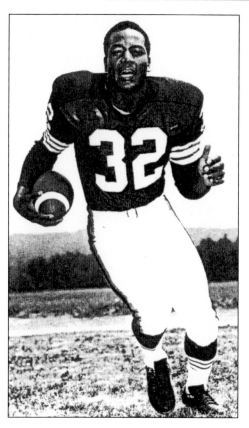

James Nathaniel Brown was born in 1936 on St. Simons Island and was raised by his grandmother until age seven when joined his mother in Manhasset, New York. When he enrolled at Manhasset High School, his sensational athletic career began. Jim was named an All-American in football and lacrosse while at Syracuse University, and was considered one of the best players to ever play lacrosse. He also excelled academically and was honored as one of five recipients of the "NCAA Silver Anniversary Outstanding Students of the Past 25 Years." Jim later played professional football with the Cleveland Browns from 1957 to 1966 and established many records. As an inductee into the NFL Hall of Fame, he is considered by many as the greatest running back in football history. Mr. Brown later turned to acting, and has appeared in over 20 motion pictures including *The Dirty Dozen* (1967), *El Condor* (1970), *Slaughter and Black Gunn* (1972), and *Mars Attacks* (1996). More importantly, he was instrumental in the establishment of the Negro Industrial and Economic Union (NIEU), Coor Golden Door and Barriers, and the Amer-I-Can Program Inc. (Courtesy of MovieVehicles.com.)

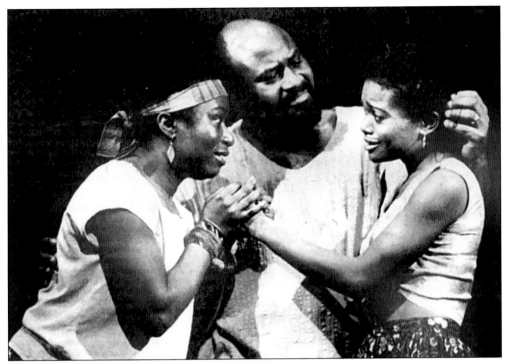

Stage and screen actor Ellis Williams was born in Brunswick in 1951, the son of Louise Collins and Eugene Williams. He graduated from Risley High School in 1969, and received a B.F.A. from Boston University. He appeared in several Broadway plays including *Once on this Island*, *Solomon's Child*, and *Pirates of Penzance*. Prior to appearing on Broadway, he toured the country with the national company of *Driving Miss Daisy*, where he was an understudy to Brock Peters and performed the role of Hoke Colenurn. (Courtesy of the *Brunswick News* archives.)

Eugene C. Tillman is seen with other unidentified cast members of the movie *Glory*, starring Denzel Washington and filmed in Glynn County in 1988. (Courtesy of Rev. E.C. Tillman.)

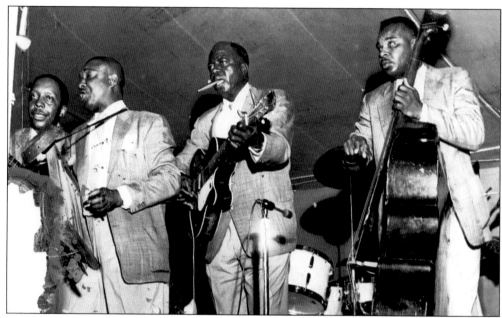

The Washboard Band was organized in 1929 by Nathan Jones in Glynn County. It has entertained R.J. Reynolds on Sapelo Island, at the Cloister Hotel on Sea Island, and has performed nationally at the Kentucky Derby and in New York City. The wonderful Washboard Band also made an appearance on the "Gary Moore Show." Pictured above, from left to right, are Smitty "Shorty" Feimster, Nathan "Abram" Jones, Robert "Washboard" Ivory, and Charles Ernest Jones. Lucious "Doc Sausage" Tyson, a Glynn County native who wrote and sang the popular song "Rag Mop" while leading a group called the Five Pork Chops, has also performed with the band. (Courtesy of Lola Jones Chappel.)

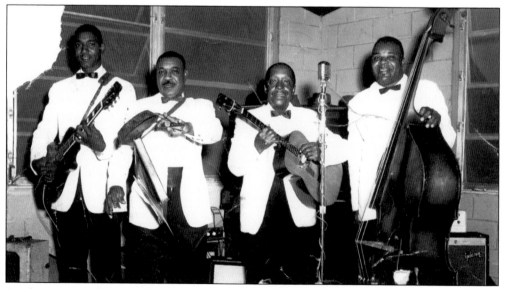

Another picture of the Washboard Band shows the members during a performance. Standing left to right are unidentified, Nathan Abram Jones (washboard), Smitty "Shorty" Feimster (guitar), and Charles Ernest Jones (bass). (Courtesy of Lola Jones Chappel.)

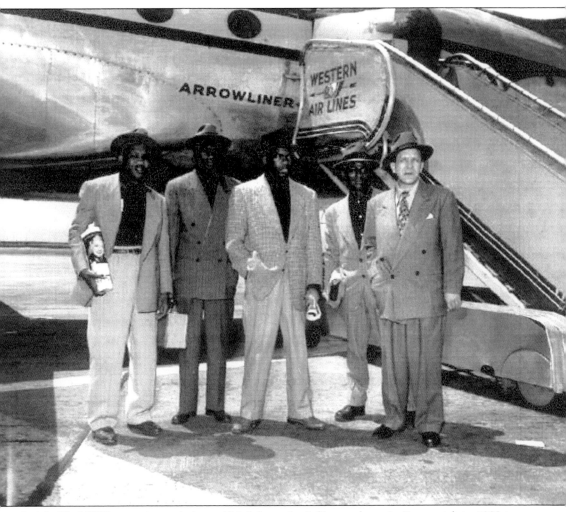

Isaiah "Ike" Williams, pictured above (third from the left), was born in Brunswick in 1923 to Isaiah Williams and his wife Della Blue. After a divorce from Ike's father, Mrs. Williams moved with her son to New Jersey where he learned to fight. The boxing career that followed spanned 15 years from 1940 to 1955. Out of a total of 153 bouts, he won 123, lost 25, drew 5, and had 60 knock-outs. Ike was reported to be among the best fighters of the 1940s and one of the greatest lightweights of all times. In August 1947, he captured the National Boxing Association 135-pound crown. Two years later, in August 1949, he gained universal recognition as world champion. He retained the title five times before losing it to Jimmy Carter in May of 1951. His last bout was a ninth-round total knock-out over Beau Jack in August 1955. (Courtesy of Loretta Knight Wright.)

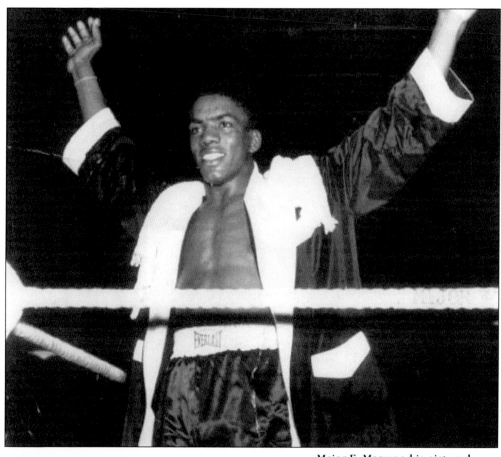

Major E. Magwood is pictured after winning the U.S. Air Force European Light-Heavyweight Championship in 1952. Fluent in several languages and recipient of many awards, C.M. Sgt. Magwood served as an interpreter for special services. As the grandson of Jane Knight, he received his early education at Risley Elementary and Junior High schools in Brunswick. He later moved to New Jersey where he gained his experience in boxing. (Courtesy of Loretta Knight Wright.)

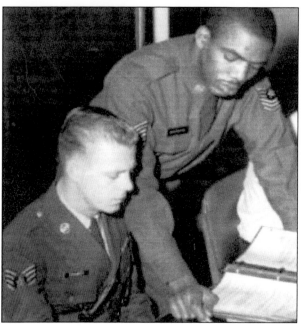

Major E. Magwood is seen giving instructions to a technical sergeant at one of his overseas duty stations. (Courtesy of Loretta Knight Wright.)

Frankie and Doug Quimby carry on with the traditions of the Georgia Sea Island singers. What once originated from the voices of slaves eventually evolved into the "Spiritual Singers of Georgia," a group organized in 1929 to sing for whites at the cabin on Lydia Parrish's St. Simons Island property and the Cloister Hotel on Sea Island. When Alan Lomax visited the islands in 1959 and 1960, he found the group still active at the Cloister Hotel on Sea Island. Singing with the group at the time was Miss Bessie Jones, who amazed Lomax with her astonishing memory of songs. Frankie and Doug, longtime colleagues of Miss Jones, are devoted to preserving this unique portion of our nation's history. They bring alive the work and escape songs, chants, and shouts created and utilized by their ancestors to persevere and prevail over the hardship of slavery. (Courtesy of *Slave Songs of the Georgia Sea Islands*.)

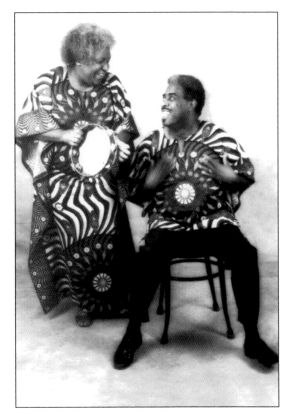

Laura Bush

July 2, 2002

Ms. Frankie Quimby
2428 Cleburne Street
Brunswick, GA 31520

Dear Ms. Quimby:

We are pleased to invite you to participate in the National Book Festival, which will be held on October 12, 2002, on the grounds of the U.S. Capitol.

The National Book Festival is a celebration of the joys of reading, books, and libraries. Approximately 70 distinguished authors and storytellers will take part.

In addition to your participation in the Festival on Saturday, October 12, you are cordially invited to a dinner at the Library of Congress on Friday, October 11, and a coffee at the White House on Saturday morning.

Your response by July 18 to Dr. John Y. Cole, Director of the Library of Congress's Center for the Book, is greatly appreciated. Dr. Cole can be reached at (202) 707-5221 or by e-mail at jcole@loc.gov. He will be pleased to answer any questions or discuss details with you.

We look forward to welcoming you to the National Book Festival, the White House, and the Library of Congress.

Sincerely,

Laura Bush

James H. Billington
The Librarian of Congress

Frankie and Doug Quimby were two of seventy distinguished authors and storytellers invited to take part in the National Book Festival on the grounds of the U.S. Capitol. They received this invitation from First Lady Laura Bush, inviting them to dinner at the Library of Congress on Friday, October 11, 2002, and coffee at the White House on Saturday, October 12, 2002. (Courtesy of Frankie and Doug Quimby.)

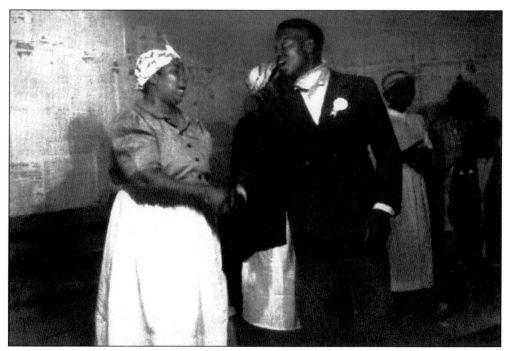

Bessie Cuyler and an unidentified man sing a farewell song at the cabin during a Sea Island Singers performance. (Courtesy of *Slave Songs of the Georgia Sea Islands.*)

Joe Armstrong and Ben Davis, two members of the Sea Island Singers, are seen as they perform during a session at the cabin. Both Joe and Ben also sang with the Shanty Singers. Having been a stevedore at the lumber yard on Gasciogne Bay, Joe was well versed in the songs and used to sing them along to the rhythm of his work. (Courtesy of *Slave Songs of the Georgia Sea Islands.*)

Born in 1895 on St. Simons Island, Bessie Cuyler was the wife of Tony Cuyler, and mother of Mildred Cuyler Abbott, Hazel Cuyler Sheppard, and James Cuyler, an original member of the Sea Island Singers. (Courtesy of *Slave Songs of Georgia Sea Islands.*)

The St. Simons Island Shanty Singers are pictured here. Shown from left to right are Floyd White, unidentified, Willis Proctor, Joe Armstrong, Ben Davis, and two unidentified men. Following the vocal leadership of a stevedore, singers would sing their songs in cadence to synchronized movements while pulling large objects from one place to another. Other rhythmic work songs were sung by factory workers while they did monotonous jobs such as shucking oysters and picking crabs and shrimp. Joe Armstrong, Floyd White, and Henry Merchant had considerable knowledge of work shanties, and were known to sing them in the old-fashioned falsetto tones, which were quite impressive when heard in open-air performances. (Courtesy of *Slave Songs of the Georgia Sea Islands.*)

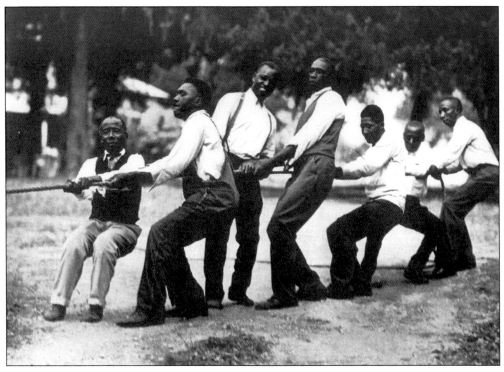

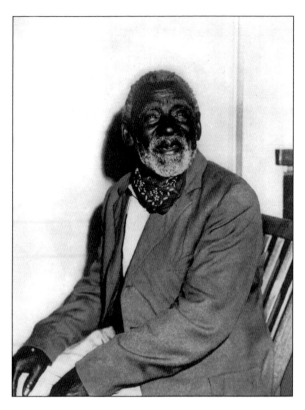

Samuel Quarterman was born on St. Simons Island in 1875, and was an integral part of the Sea Island singers. He regularly preformed at the Cabin and the Cloister. Several photos of him can be seen on the internet from Alan Lomax's documentation of folk singers in Georgia. (Courtesy of *Slave Songs of the Georgia Sea Islands.*)

This photograph is of Willis Proctor of St. Simons Island, where his ancestors lived for many generations, *c.* 1940. His mother was Mina, the daughter of Robert Merchant, a slave from Retreat Plantation. Willis's Father was Adam Proctor, who belonged to the Goulds of Black Banks Plantation. For 10 years Willis was in charge of the dining room at Arnold House on St. Simons. He also held a similar position at the Georgia Military Academy at College Park, worked for the Jekyll Island Club, and became a personal valet to William Rockefeller at his Indian Mound home on Jekyll Island. Mr. Proctor was also a leader among the Georgia Sea Island singers who kept alive the old slave songs of his race. (Courtesy of *Slave Songs of the Georgia Sea Islands.*)

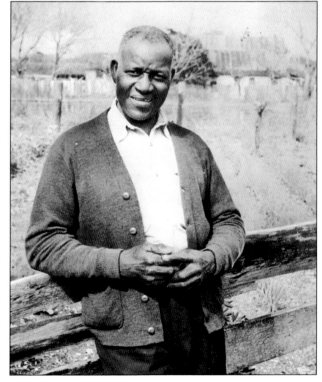

Charles Clarence Dawson was born in Brunswick in 1899. He graduated from Tuskegee Institute with honors in 1909; attended the Art Students League of New York between 1907 and 1912; and graduated with honors from the Art Institute of Chicago in 1917. He also served as captain of an infantry division (1917–1919) during World War I. Dawson was a freelance painter, illustrator, designer, and curator for the installation and development of New Museum of Negro Art and Culture at the Tuskegee Institute in Alabama. He was the recipient of the Eames McVeagh Prize, Jessa Binga Popularity Prize, Charles S. Peterson Prize, and Harmon Award for distinguished achievement in the fine arts. His works were exhibited in Pretoria, South Africa, in 1929. (Courtesy of *Who's Who in Colored America*, seventh edition.)

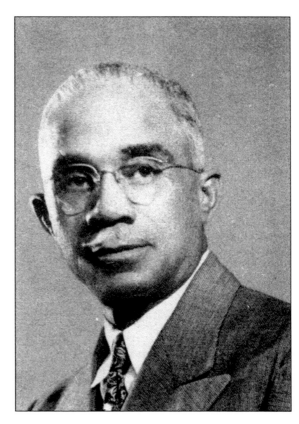

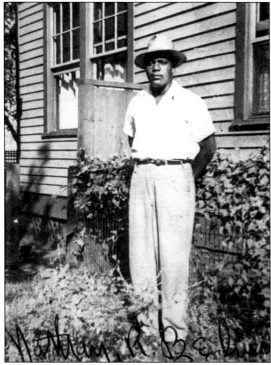

Pictured here is Nathan R. Belvin, brother of Maudie Lou Jones, who was the wife of the Washboard Band's Abram Jones. Belvin was a member of the famous Silas Green Band, which wintered each year in Brunswick. He also gave music lessons to local Brunswick youths, among whom were Thomas E. McCloud and Ernest Stuart. (Courtesy of Lola Chappel.)

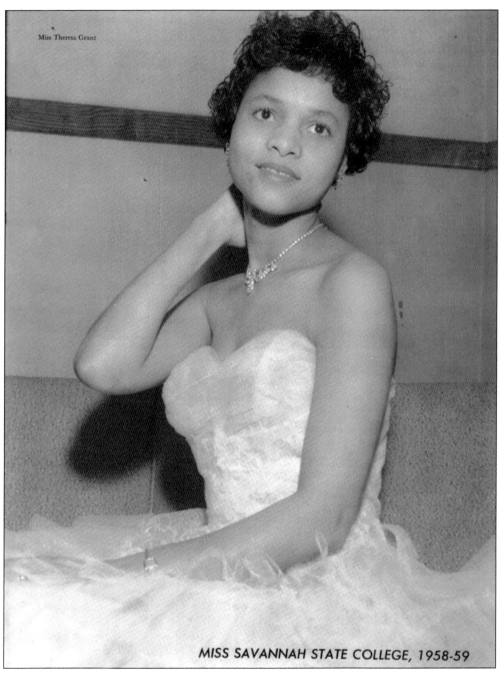

Miss Theresa Grant

MISS SAVANNAH STATE COLLEGE, 1958-59

Theresa (Grant) Atkinson, daughter of James Grant Sr. and Mamie (Wright) Grant, was Miss Savannah State College 1958–1959. A graduate of Risley High School's class of 1955, she graduated from Savannah State College in 1959 and taught school in the Glynn County School system for over 30 years. She is the wife of Francis Michael Atkinson, who is the retired principal of Altama Elementary School. (Courtesy of Savannah State College archives.)

John H. Johnson was born in Brunswick in 1908. He graduated with an A.B. from Claflin College in 1925 and Eckles College of Embalming in 1927. In 1935, he was director of Centennial Choir, and directed the Shiloh Baptist Church Choir from 1938 to 1948. He also organized the Orlando Community Boys Club, which was the first African-American boys club in Florida. (Courtesy of *Who's Who in Colored America*, seventh edition.)

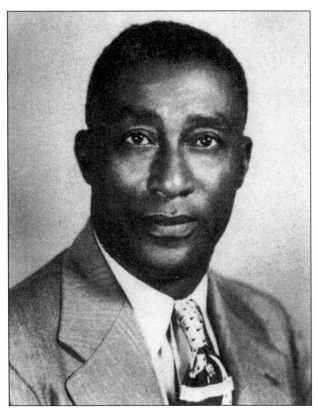

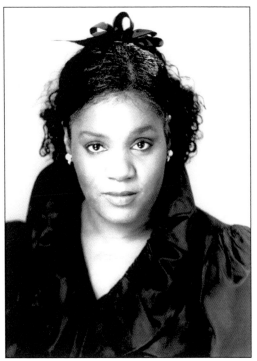

The internationally known soprano Marilyn Moore Brown was born in Brunswick to Mr. and Mrs. Willie Moore. Julia Ford of Brunswick was Brown's first voice instructor. She has performed as a featured soloist at Carnegie Hall, Lincoln Center, Philadelphia Academy of Music, the Spoleto Festival in Charleston, South Carolina, and the John F. Kennedy Center. She has also performed in operas ranging from Purcell's *Fairy Queen*, Mozart's *Die Zauberflote*, and Strauss's *Ariadne auf Naxos* to the role of Bess in *Porgy and Bess* with the Teatro Municipal in Rio de Janiero. (Courtesy of Mr. and Mrs. Willie Moore.)

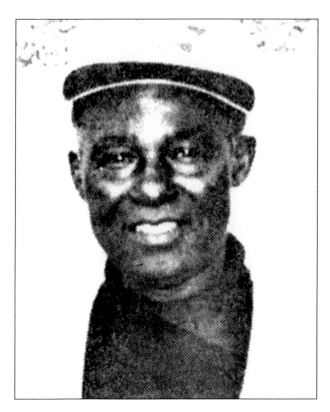

Earl Hill was born in Glynn County and was educated at Selden Normal and Industrial Institute. He was an active owner of the Blue Inn, a popular night spot for many of Glynn County's African Americans during the 1940s and 1950s. Hill was married to Matilda "Tilly" Denegal of Jekyll Island and was the father of Barbara Hill Floyd.

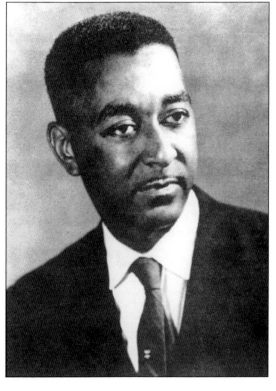

Brunswick native Genoa Martin served as assistant director, and then director, of Selden Park from 1948 to 1985. Martin promoted rhythm and blues and jazz groups performances in Brunswick, including Duke Ellington, Buddy and Ella Johnson, James Brown, Ruth Brown, Cab Calloway, Lionel Hampton, and Bobby "Blue" Bland. As well as providing radio commentary for Risley High football games, he was the first African American to host a radio show on WGIG. (Courtesy of Benjamin Allen.)

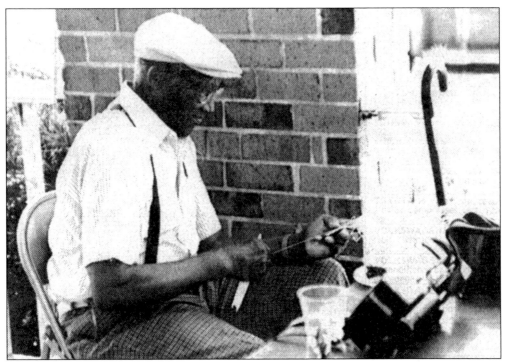

Frank Hunter was born on St. Simons Island and is seen making a fishing net during the Georgia-Sea Island Festival. Net-making is a skill that was common practice in practically every black household in the early part of the 20th century; today it is almost a lost art as very few of the young men have continued the tradition. (Courtesy of the *Brunswick News*.)

Miss Savannah State College of 1959, Theresa Grant, and her court are seen in the Homecoming Parade. In the foreground are Iris Parrish (left) and Kay Francis Stripling (right). (Courtesy of the 1959 *Savannah State College Yearbook*.)

Local cast members of the movie *Glory* pose during a break in filming on Jekyll Island. (Courtesy of Shiloh Baptist Church.)

Selden Park, a public park near the banks of the Turtle River, is built on the site of the former Selden Normal and Industrial Institute. The Institute, once considered one of the finest black educational facilities of its time, opened in 1903 and pioneered in the intermediate education of blacks throughout the coastal area. The school was named after Dr. Charles Selden, a missionary noted for his work in China, who purchased the land for the facility. It closed its doors in 1933 and ultimately was donated to Glynn County as a public park for blacks. (Courtesy of *African-American Heritage Highlights*.)

Five

CITY, STATE, AND NATION
GOVERNMENT SERVICES

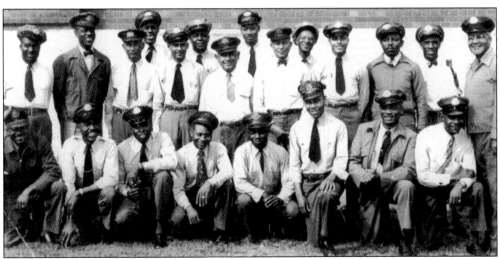

In 1890, when mail services began in Brunswick, five African-American mail carriers were appointed, including Oliver M. Buggs, Henry Molding, George Abbott, W.H. Myers, and O.F. Pyles. This is a picture of Brunswick mail carriers *c.* 1950. Kneeling in the front row (from left to right) are G. Dawson, A. Hose, B. Jaudon, unidentified, L. Green, J. Eppings, E.V. Wright, and P. Rhaney. In the back row (from left to right) are R. Nelson, H. Cuthbert, E. Council, L. Moore, E. Lewis, T.D. Pickens, J.P. Monroe, D. Lucas, J.P. Atkinson, C. Walters, H. Coleman, G. Baskin, H. Armstrong, and S.G. Dent. (Courtesy of Albert Hose.)

Joseph M. Atkinson, born in Brunswick in 1909, was a graduate of Selden Normal and Industrial Institute. As the manager of African-American public housing projects in Brunswick, he was active with local organizations and served as a sports referee in local football games. Mr. Atkinson was one of 17 children born to Clement and Mary E. Atkinson. His mother was a local midwife and was honored as Glynn County's "Negro Mother of the Year." Among her sons, three were physicians, one an attorney, one an electrical engineer, and one a barber examiner. Her daughters included a high school librarian, a beautician, a public health nurse, a church worker, and several housewives. (Courtesy of *The Brunswick News.*)

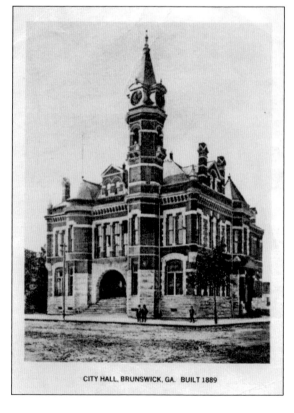

CITY HALL, BRUNSWICK, GA. BUILT 1889

This postcard shows Old City Hall located on the corner of Mansfield and Newcastle Streets, *c.* 1925. The architect was Alfred S. Eichberg, and Anderson and Sharp served as the contractor. (Courtesy of Benjamin Allen.)

NEWCASTLE STREET, LOOKING SOUTH BRUNSWICK, GA.

This postcard gives a view of Newcastle Street looking south toward Mansfield Street and Old City Hall, *c.* 1925 (Courtesy of Benjamin Allen.)

THE CASINO, SAINT SIMONS ISLAND BRUNSWICK, GA.

The Old Casino on St. Simons Island, near the Pier off Mallory Street, can be seen in this postcard, *c.* 1925. (Courtesy of Benjamin Allen.)

LIGHTHOUSE, SAINT SIMONS ISLAND BRUNSWICK, GA.

This postcard shows St. Simons Island Lighthouse, *c.* 1925, located off Mallory Street near Neptune Park. (Courtesy of Benjamin Allen.)

LANIER'S BATH HOUSE. BRUNSWICK, GA.

Lanier's Bath House, which was on what is now Lanier Boulevard or U.S. 17 and close to Lanier's Oak, appears in this postcard from *c.* 1925. (Courtesy of Benjamin Allen.)

GLOUCESTER, LOOKING EAST. BRUNSWICK, GA.

This postcard shows Gloucester Street looking east toward Norwich Street, *c*.1925. (Courtesy of Benjamin Allen.)

BRUNSWICK FIRE DEPARTMENT (about 1925) ON NEWCASTLE AND MANSFIELD STREET - EXACTLY IN FRONT OF CITY HALL.

This postcard shows the City of Brunswick Fire Department *c*. 1925 on the corner of Newcastle and Mansfield Streets in front of old City Hall. (Courtesy of Benjamin Allen.)

NAVAL STORES DOCKS. BRUNSWICK, GA.

A postcard depicts the Naval Stores Docks located on Bay Street at the foot of London Street, *c.* 1925. (Courtesy of Benjamin Allen.)

SEA ISLAND YACHT CLUB, SAINT SIMONS ISLAND BRUNSWICK, GA.

This postcard shows the Sea Island Yacht Club *c.* 1925. The Yacht Club was located near the Cloister on Sea Island. (Courtesy of Benjamin Allen.)

Orion L. Douglas, a 1964 St. Pius X graduate, received his A.B. degree in philosophy from College of the Holy Cross. Later he obtained a J.D. from Washington University in St. Louis, Missouri. From 1981 to 1992, Douglass served as a municipal court judge in Glynn County. Currently, he is serving a third term as judge of Glynn County State Court. (Courtesy of Charles Elmore.)

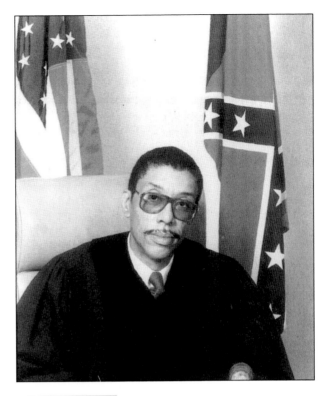

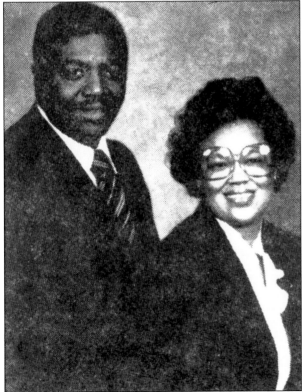

This picture shows Capt. James and Carolyn Baker. James was born in Brunswick and graduated in the Risley High School class of 1957. He became the first black law enforcement officer hired by the Glynn County police department and eventually attained the rank of captain before his retirement. His wife Carolyn is a registered nurse and was employed by the Glynn Memorial Hospital. (Courtesy of Captain James Baker's retirement party program.)

Brunswick city official James A. Stephens
was born in McIntosh County in 1914.
His education brought him to the
Franklin Institute and the University of
Georgia, where he received a certificate
in banking and finance. He retired from
the post office in 1940, and served as an
equal opportunity liaison for the Atlanta
Life Insurance Company. In Brunswick
he served as the city commissioner
and as the chairman of the board of
directors of the Center for Promotion
and Development of Communities from
1980 to 1981. He was also chairman
of the Glynn County Boys' Club. He
married Lillie Mae Stephens and is
the father of Charles R., James A. Jr.,
and Herbert C. Stephens. (Courtesy of
Who's Who Among Black Americans.)

Thomas P. Williams, a Brunswick native, served
as Brunswick County Commissioner and
three terms as Brunswick's pro tem mayor. He
received his baccalaureate degree from Clark
College (Atlanta), and a master's degree from
New York University. Williams also served as
a principal in Folkston, Georgia, at McIntosh
Academy in Darien, and worked extensively
with the Veteran Trade School in Brunswick.

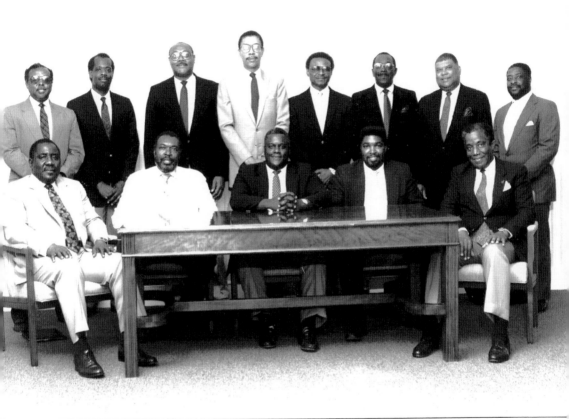

Recognizing that the young black men of Glynn County needed help in improving their chances for success, Fourteen Black Men of Glynn Inc. organized to give something back to the community. Pictured from left to right are (front row) Edward Pinckney Jr., Joseph Jaudon, John Culbreath, Odis Griffin, and Albert Armstrong; (back row) Robert Griffin, Greg Lattany, Benjamin Allen, Orion Douglas, Michael Atkinson, David Whitfield, William "Buck" Crosby Sr., and Roosevelt Harris. Other members not shown are Jonathan Williams, Col. Thomas Fuller, and Ray Ford. The mission of the group was to mentor and provide guidance and tutoring support for the young men, and to provide them with college scholarships. (Courtesy of Benjamin Allen.)

Freeman Hankins was born in Brunswick in 1918 and graduated from Selden Normal and Industrial Institute. He served in the United States Army during World War II, and was later elected to the Pennsylvania House of Representatives (1961–1966) as well as the Pennsylvania State Senate (1967–1989). He was active in the NAACP, American Legion, Amvets, Freemasons, Elks, and Woodmen. (Courtesy of *Pennsylvania Enquirer Archives*.)

Curtis L. Atkinson was born in Brunswick in 1934. He attended Howard University from 1953–1954 before moving on to receive his B.S. from Fort Valley State College in 1956. Atkinson then went into teaching before acquiring an M.S. from Columbia University in 1969. Following that, he served as a staff member in the office of Herman Talmadge, U.S. Senate, until 1980. He was also assistant secretary of state in Georgia (1983–1996) during Max Cleland's tenure as secretary of state. Atkinson was very active in civic affairs, and served on the executive committee of the Georgia Special Olympics in 1984, the board of directors of the Georgia Alliance for Children, and the Fort Valley State College Foundation. He was also a chairman/secretary on the state's Economic Development Task Force.

A native of Brunswick, John Allen Buggs was born in 1915 to Leonora Clark and Dr. Charles Wesley Buggs Sr. (the first black physician in south Georgia). John graduated from Colored Memorial in 1933, received a B.A. from Dillard University, a M.A. from Fisk University, and finally was awarded an honorary doctorate of humanities from Chapman College in California. He served under President Carter as staff director of the Model Cities Administration at HUD from 1967 to 1969 and as vice president of field operations for the National Urban Coalition from 1969 to 1971. In 1971 he was appointed by President Nixon as executive director of the United States Commission on Civil Rights and continued in that capacity under President Ford. (Courtesy of *Distinguished Negro Georgians* and Lenora Massey Gary.)

Douglas C. Green was born in Brunswick in 1910. He graduated from Selden Normal and Industrial Institute and continued on to receive his bachelor's, master's, and Ph.D degrees. He was raised in the Dixville section of Brunswick on the corner of Bartow and London Streets and was employed by the City of New York's social services department. (Courtesy of *The Brunswick News.*)

103

Cauree Rogers Allen Dawson was born in Fitzgerald, Georgia, in 1921. She was brought to Brunswick at a very young age and attended and completed Colored Memorial School. Because the 1930s was such a difficult economic period she left school to help support her family. She married Benjamin "Pep" Allen in 1938; to this union four children were born: Benjamin, Catherine, Lester, and Doretha. Never forgetting the lean days of the 1930s, she made it a tradition to always prepare enough food daily to feed anyone who showed up in need of a meal. On holidays she had an open-door policy and everybody was welcome. She was known for her deviled crab, crab cakes, and fruit cake. Cauree married Joseph Dawson after divorcing her first husband, and three children were born to that union: Kenneth, Gerald, and Deborah. (Courtesy of Benjamin Allen)

Catherine A. Allen Armstrong was born in Brunswick and graduated from Simon Gratz High School in Philadelphia, Pennsylvania. After attending Penn State University, she returned to Brunswick in the early 1970s and became an integral part of the movement to secure federal jobs for African Americans at the Federal Law Enforcement Training Center (FLETC). While at FLETC she became aware of unfair housing opportunities for blacks and launched a campaign to promote fair housing with the help of Attorney General Robert F. Kennedy. After leaving FLETC she became a legal assistant with Georgia Legal Services for more than 10 years and was also the first black administrative assistant in the Judge Advocate office. She is married to Albert R. Armstrong, minister at New Covenant Church. (Courtesy of Benjamin Allen.)

The 1963 "March on Washington" was sponsored with the help of the Ladies Garment Workers Union, District 65. They strategically planned to follow up their march with an effort to place more blacks in management positions with major corporations. Brunswick native Benjamin Allen was among the first group of young blacks placed in one of these positions, and he worked for Lerner Stores Corporation at its offices in New York and Pittsburgh for 20 years. Pictured above is the Ladies Dress Department team *c.* 1965, including (from left to right) Benjamin Allen (Assistant Department Head), Lenore Price (Assistant Buyer), Gerhard Singer (Department Coordinator), Emma Moses (Buyer), and Wally Siegal (Department Head). (Courtesy of Benjamin Allen.)

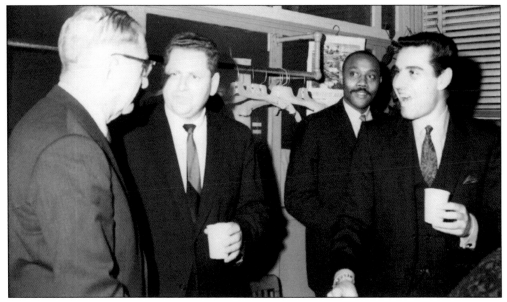

This picture is from a Christmas party gathering in the Ladies Dress Department, *c.* 1965. Posing from left to right are Harold Lane Sr. (Chairman of the Board of Lerner Stores Corporation), Gerhard Singer (Department Coordinator), Benjamin Allen (Assistant Department Head), and Gary May (CEO of May Dress Company). (Courtesy of Benjamin Allen.)

Alexander Atkinson graduated from Selden Normal and Industrial Institute and later received a B.S. in electrical engineering. He was born in Brunswick in 1914 to Clement and Mary Miller Atkinson. (Courtesy of *The Brunswick News.*)

Julia (Minor) Life was born in Brunswick in 1905 to Judson and Enos Minor. She attended Spelman College and taught for a number of years at the Arco School. When it closed she moved on to the Hercules Powder Company. She is the sister of Eunice Minor and the mother of Edward Life III, Lois (Life) Screen, Mildred (Life) Gray, and Johnny Minor Life. (Courtesy of Benjamin Allen.)

Six

MILITARY

Neptune Park is an excellent place for those wishing to stroll through a relaxing atmosphere. It offers an uncrowded fishing pier and quiet paths through ancient oaks with dripping beards of Spanish moss. (Courtesy of Benjamin Allen.)

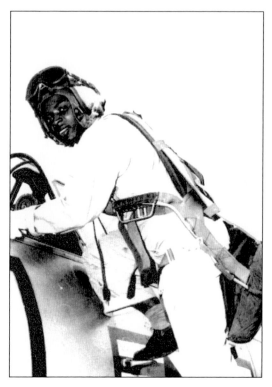

Clifford Gibson was born in Brunswick, the oldest child of Leroy Gibson and the stepson of Christie Lee Brown. After graduating from Risley High School as valedictorian of his class, he went on to receive a bachelor's degree from Morris Brown College in Atlanta, Georgia. Immediately after college he entered the U.S. Navy, married his college sweetheart Miriam, and became a career serviceman. He rose to the rank of Lt. Commander and was one of the first black jet pilots from Glynn County. (Courtesy of Loretta Knight Wright.)

Pictured below are Ensign and Mrs. Clifford Gibson after their wedding. (Courtesy of Loretta Knight Wright.)

Creola Barnes Belton was born in 1921 on St. Simons Island. She graduated from Risley High School in 1939 and received her R.N. degree from Augusta Hospital School of Nursing. Belton was commissioned as a First Lieutenant in the U.S. Army c. 1942 and later served veterans by teaching a licensed practical nursing course at the Veterans School on Stonewall Street in Brunswick. (Courtesy of Creola Barnes Belton.)

Theodore R. Bess was born in 1945 to Arthur Lee Bess and Catherine Bess Manning. He graduated from Risley High School in 1962 and earned a B.S. in computer science in 1970 while serving in the U.S. Air Force. In 1971 he was commissioned as a Second Lieutenant and rose to the rank of Captain before his discharge in 1976. He returned to Brunswick in 1988 and worked as a computer technician for Brunswick College. (Courtesy of Benjamin Allen.)

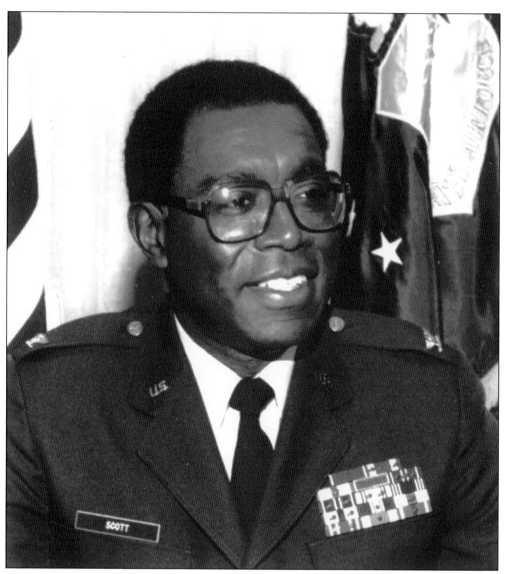

James H. Scott was born on St. Simons Island in 1942. After graduating from Risley High School in 1960, he enlisted in the United States Air Force, and through off-duty education qualified for the Bootstrap Commissioning Program. He eventually earned a B.B.A. degree from Golden Gate University in 1969 and received his M.B.A. in 1971. Scott was commissioned in 1969; after that point he completed the Squadron Officer School in 1973, Air Command and Staff College in 1976, the Armed Forces Staff College in 1980, and the Air War College in 1984. Colonel Scott served as chief of services at Kunsan Air Base in Korea and as services inspector and inspection analyst for the Inspector General's office at Randolph AFB in Texas. In May 1988 he became the Commander at the Headquarters Air Force Commissary Service (AFCOMS) of the Pacific region and served in that position until consolidation of all services commissaries. He retired as a Colonel from the Air Force in 1995 after 35 years of service. He then went to work at U.S.A.A. Insurance Company for five-and-a-half years as assistant vice president and chief of corporate procurement. James is the younger brother of another USAF officer, Maj. Samuel Scott, a member of Risley High School's class of 1959. (Courtesy of Col. James Scott.)

Seven

MEDICAL PIONEERS

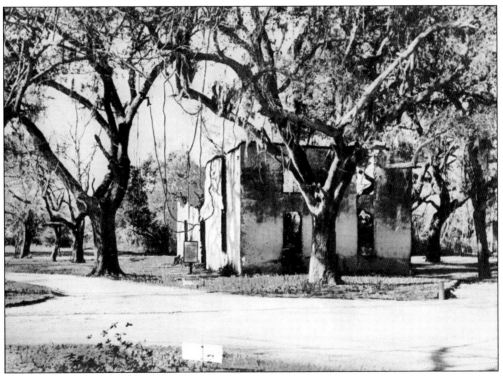

Pictured here is Retreat Hospital, a 10-room tabby building, which was the slave hospital of Retreat Plantation. The rooms on the ground floor were for women, the second floor for men, and two hospital nurses lived in the attic. Each room measured 12 by 15 feet with a fireplace and two windows. Slave hospitals were not common, but where they existed, the mistress of the plantation (such as Mrs. Thomas Butler King of Retreat Plantation) supervised the care of sick slaves. Mrs. King, in her hospital record book, itemized the births, deaths, and illnesses of slaves. (Courtesy of *Early Days of Coastal Georgia*.)

Whittier C. Atkinson was born in Camden County, Georgia, in 1893, the son of Clement and Mary Miller Atkinson of Brunswick. Atkinson graduated from Georgia State Industrial College's high school division (Savannah, Georgia), and received a B.S. (1922) and a M.D. (1925) from Howard University. In 1937 he founded Clement Atkinson Memorial Hospital in Coatesville, Pennsylvania, and served as its director for 25 years. He was the first black doctor elected president of a county medical society in Pennsylvania—only one of three in the nation at the time of his election. He was a member of the American Medical Association, the National Medical Association, and the American Academy of General Practice. (Courtesy of *Who's Who in Colored America,* seventh edition.)

Margaret Mitchell-Bateman, M.D., a graduate of Selden Normal and Industrial Institute, went on to become a great physician and the first female from Selden Normal to enter the profession. (Courtesy of Selden Normal and Industrial Institute Archives.)

Margaret Floyd Banks was born in Brunswick and graduated from Selden Normal and Industrial Institute. She then received her R.N. degree from Grady Nursing School in Atlanta, Georgia and worked as a nurse in Atlanta until her retirement. (Courtesy of Benjamin Allen.)

A native of Brunswick, Pansey Perry graduated from Risley High School and received her R.N. degree from Kate Bitting School of Nursing in Winston Salem, North Carolina. She is married to Henry Perry and is the mother of three children: Leila Perry Davis (teacher), Margaret Perry (hospital administrator), and Kevin Perry (school principal). (Courtesy of Pansey Perry.)

Eugene Vallion Jr., the son of Eugene and Ella Vallion Sr., was born in Sterling in 1930. He graduated from Risley High School in 1949, attended Savannah State College, and received B.S. from Central State College in 1959. He went on to Meharry Medical College and completed his D.D.S in 1965. He married and raised three children. (Courtesy of Eugene Vallion Jr.)

Chazzie Skipper was born in Brunswick and was educated at Selden Normal and Industrial Institute. She earned a R.N. degree and was employed by the Glynn Brunswick Memorial Hospital for many years before her retirement. (Courtesy of Benjamin Allen.)

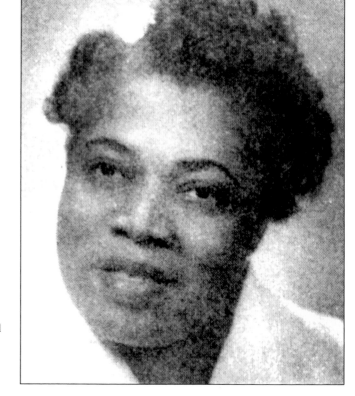

Pauline Williams Collins, daughter of Paris and Bertha Young Williams, was born in Camden County in January, 1930. She married Elve Atkinson in 1947 and later married Eugene Collins in 1972. She was a licensed practical nurse and a member of the National Association of Practical Nurses. (Courtesy of Gerri Chapman Culbreath.)

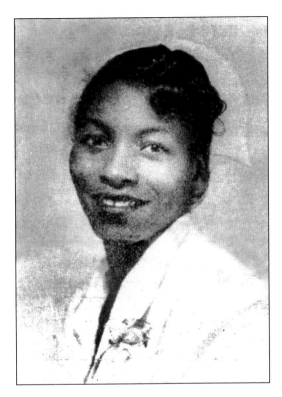

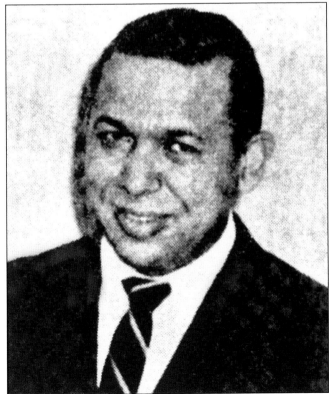

Dr. C.T. Atkinson was born in Brunswick, the son of Clement and Mary Miller Atkinson. He is a graduate of Selden Industrial and Normal Institute. (Courtesy of Selden Normal and Industrial Institute Archives.)

This is another picture of Creola Barnes Belton, who was born on St. Simons Island in 1921. Belton was a lieutenant in the U.S. Army and a longtime employee of the Glynn Brunswick Memorial Hospital. (Courtesy of Jackie and Michael Traeye.)

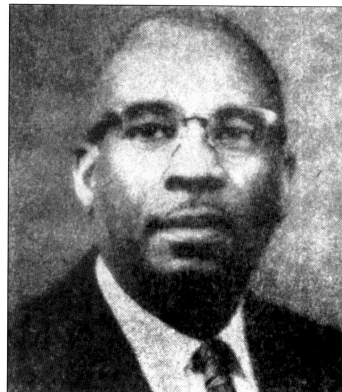

Wendall P. Holmes Sr. was a mortician and owner of Holmes Funeral Home, which was located on "I" for a number of years. He is the father of Wendell P. Holmes Jr., who is a graduate of Hampton Institute and Eckels College of Mortuary Science. (Courtesy of *African American in the Southeast*.)

Eight

FAMILY ALBUM

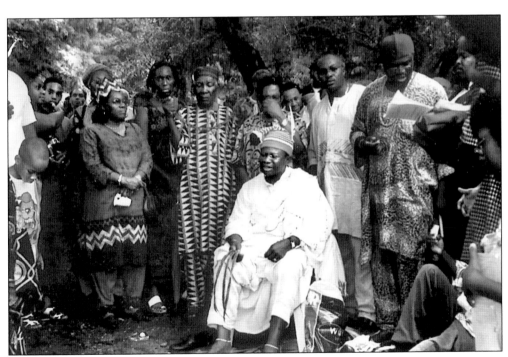

Representatives from the Ibo tribe, along with Christian and Jewish representatives and guests, gather on August 31, 2002 at Ibo Landing on St. Simons Island to commemorate the 199th anniversary of the slave drowning that took place at the site. Representing Eze Nri, Okpala Eze Chukweumeka Onyesoh (the high priest and ultimate spiritual guide of the Ibo tribe) is seen sitting in the center. (Courtesy of *The Brunswick News*.)

Edward Washington Wright was born in Camden County in 1863 to a white father and black mother. Wright was raised by his paternal Scottish grandmother. He married Julia Sadler in Camden and later he and his children—Annie C. (Wright) Allen, Lillie (Wright) Sams, Charles Edward Wright, Mary (Wright) Grant, and Elizabeth (Wright) Woodard—moved to Brunswick. (Courtesy of Benjamin Allen.)

Annie Charlotte Wright Allen was born in Camden County in 1888, the oldest daughter of Edward Washington Wright and Julia Sadler Wright. She arrived in Brunswick as a child, and later married Benjamin J. Allen Sr. From this union five children were born: Juliette Allen Snead, Annie Ruth Allen Stevens, Benjamin J. Allen Jr., Charlotte Allen, and Elouise Allen Downs Polite West. Annie would often tell how when she came to Brunswick from St. Mary's the only method of transportation was by boat. She lived to be 101 years old and died in 1989. (Courtesy of Benjamin Allen.)

Mary (Wright) Grant, daughter of Edward W. and Julia Sadler Wright, was born in 1893. She became a wife to James "Jim" Grant, and the mother of James Grant Jr., Audrey Grant Baker, Clara Grant Lewis Childs, John Grant, Alfred Grant, Theresa Grant Atkinson, Alex Grant, Robert Grant, Rose Grant, and William Grant. (Courtesy of Benjamin Allen.)

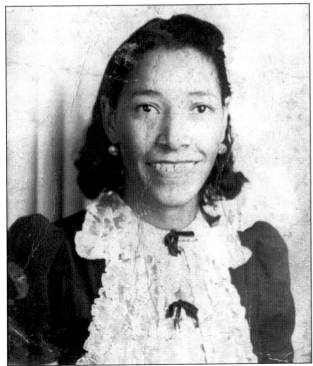

Elizabeth Wright Woodard was born in Brunswick in 1909. This daughter of Edward W. and Julia Sadler Wright resided and worked in New Jersey for many years before returning to Brunswick. She is the mother of Leroy "Dottie" Wright. (Courtesy of Benjamin Allen.)

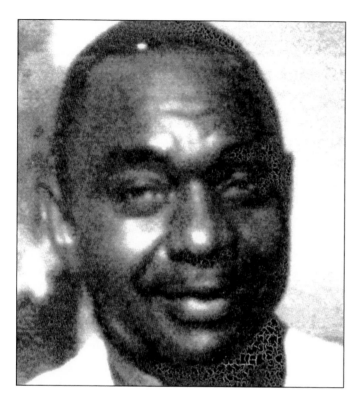

Thomas Clinton "M.C." Knight was born in Brunswick in 1916, one of four children of Moses and Gertrude Knight. He was self employed and repaired radios and televisions. In later years, Knight worked in electronics and as a radar analyst at Warner Robbins Air Force Base in Marietta, Georgia. He married Ruth Brown Knight, and was the father of Gwendolyn Knight Humphrey, Loretta Knight Wright, and Genevieve Knight. (Courtesy of Loretta Knight Wright.)

Ruth Brown Knight, wife of Thomas Clinton Knight, was born in Coffee County, Georgia, but moved to Brunswick at an early age. She worked as a seamstress whose clientele included a local white judge's wife, a tax commissioner's wife, and many other distinguished (and not-so-distinguished) local residents. (Courtesy of Loretta Knight Wright.)

Jasper Barnes (left) was born in 1915 and is the brother of the late Morrison Barnes (right). This photograph is from *c.* 1942. Jasper opened the LaQuartz Club on St. Simons Island and continued as owner until the 1980s. He was the first black to run for Islands Commissioner in 1972, but lost after a tight runoff election. (Courtesy of the Barnes Family.)

Preserving the Past

Coastal Cultural Heritage

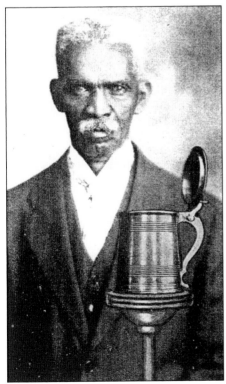

Morris Seagrove was the last of his race to own the Butler Cup. It was customary for the Butler negroes who worked the cotton fields on Little St. Simons to make the daily trips back and forth from Butler's Point in boats, for there were no dwelling houses on Little St. Simons, the only structure being a hurricane house built to withstand the tropical gales. In September of 1804, a storm came up while more than a hundred of the Butler negroes were working on Little St. Simons. The head driver Morris, realizing the futility of attempting to return to Butler's Point in such a gale, ordered the negroes into the hurricane house and by his clear thinking saved their lives. Maj. Pierce Butler, wishing to reward Morris for his splendid conduct, offered him his freedom, which he declined. Major Butler then presented him with a sum of money and a silver cup, on which was engraved the following inscription: "To Morris from P. Butler, For his faithful, judicious, and spirited conduct in the hurricane of September 8, 1804, whereby the lives of more than 100 persons were by Divine permission, saved." *(Courtesy of Our Todays, and Yesterdays)*

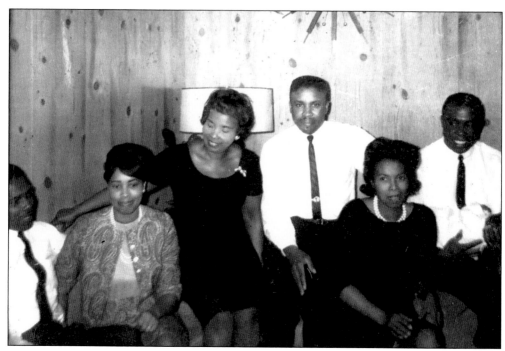

Pictured above is a Palmer family gathering. Shown from left to right are Saul Palmer Jr., Ruby Palmer Holmes, Geneva Jenkins, Monroe Palmer Jr., Audrey McArthur, and Warren G. Palmer, Ph.D. (Courtesy of Diane Palmer Holloway.)

Albert and Phyllis Sullivan were from the Hofwyl Plantation and were related to Old Tom (whose African name was Sali-bul-Ali) of Sapelo and St. Simons Islands. The Sullivans were Moslems and are the grandparents of Pat and Vera Gary. (Courtesy of Lenora Massey Gary.)

Harriet Murray Sheppard was born on St. Simons Island in 1886. She was the wife of Soney Sheppard and the mother of Norris "45," Soney, Harriet, and Reggie Sheppard. (Courtesy of Helen Sheppard Allen.)

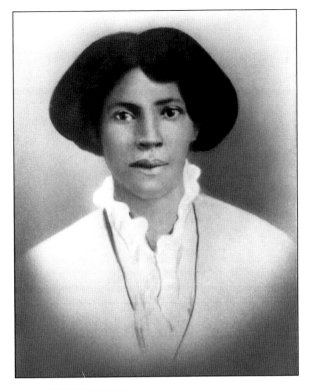

Norris "45" Sheppard, a life-long St. Simons Island resident, is shown at his retirement from the Sea Island Company after 47 years of service. Here I.A. Harned presents him with a token of appreciation for his years of service. Sheppard delivered oil and chauffeured company guests for years between Jacksonville, Thalman, and Savannah to the Cloister Hotel and the Cottages. He also drove Queen Juliana of the Netherlands, Sarah Churchill, and many other rich and famous visitors to and from St. Simons Island. (Courtesy of Helen Sheppard Allen.)

Dr. C.T. Atkinson (left), his wife Marion, and his brother J.M. Atkinson appear together at a Selden Normal and Industrial Institute Alumni Association class reunion. Other members of Selden's alumni, who are not pictured here, are Harrison H. Cain, Lucille Atkinson, Leroy H. Harmon, Daisy M. Way, Chazzie Skipper, Freeman Hankins, Mildred Mitchell Bateman, M.D., Margaret F. Banks, R.N., Douglas C. Green, Ph.D., Wendell P. Holmes, Rufus P. Perry, Ph.D, and Herbert R. Pinkney, Ph.D. (Courtesy of Selden Normal and Industrial Institute Archives.)

Elias Blake (left), former president of Clark College in Atlanta; Curtis Atkinson (center), former congressional aide to Senator Herman Talmadge and former Georgia assistant secretary of State; and Willie David Baldwin (right) are shown discussing old times at a Risley High School class reunion in the 1980s. (Courtesy of Benjamin Allen.)

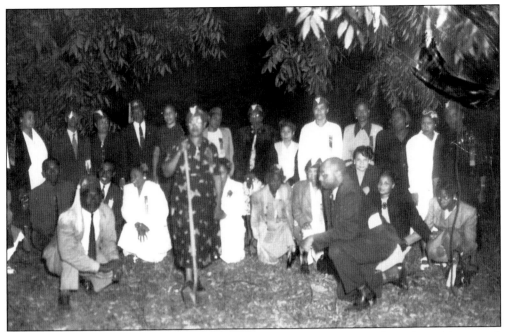

Alfonso Ramsey is kneeling on the left while Reverend Mann kneels on the right at this ground-breaking ceremony for the Elks Club. Mamie White and Mrs. L. Dixon also appear in the photograph. (Courtesy of Willie and Gloria Simmons.)

Pictured is a group of unidentified men. The gentleman kneeling on the right is believed to be Mr. Dixon, father of Annie Clara, Lola, and Lorene. (Courtesy of Willie and Gloria Simmons.)

Audrey Grant Baker was born in Brunswick *c.* 1940, the oldest daughter of James "Jim" and Mamie Ellen Grant. She is married to Ed Baker. (Courtesy of Benjamin Allen.)

Standing from left to right are Bacon, Dr. Tommie McCloud, Dr. Elias Blake, and Raymond Davis Esquire. (Courtesy of Benjamin Allen.)

Emma Murphy was the wife of Edward Murphy, who owned Murphy Taxicab Company, and mother of Nina and Edward Jr. Mrs. Murphy worked as a swimming aide for over 25 years at the beach club pool in the Cloister Hotel. (Courtesy of *This Happy Isle.*)

Elouise Allen Downs Polite West was born in Brunswick in 1921. She is the daughter of Benjamin and Annie C. Allen and the mother of Robert Downs, Arthur Downs, and Hattie C. Polite. (Courtesy of Benjamin Allen.)

OTHER NOTABLE GLYNN COUNTY AFRICAN AMERICANS

Photographs of the following individuals were not available for this publication:

Nathaniel "Junior Armstrong: B.S., Talladega; M.S. University of Pittsburgh; M.D. Howard University Medical School.

Nolan Atkinson, M.D.: son of Clement and Mary Miller Atkinson.

Ralph Baisden, Captain U.S. Air Force: received both a bachelor's and master's degree.

George R. Baldwin, attorney: B.A. Lincoln University, 1955; LL.B J.D. Brooklyn Law School, 1964; LL.M. New York University Law School, 1976.

Haley W. Bell, dentist: D.D.S. Meharry Medical College, Nashville, Tennessee.

Henry James C. Bowden: B.A. Morehouse College; M.A. Columbia University.

Warnell Brown, C.P.A.: B.S. Morris Brown College.

James G. Carter, U.S. Consul to Madagascar, 1907.

William "Buck" Crosby, administrative assistant to Glynn County Schools and interim superintendent.

Clarence Daniels, principal: Risley class of 1957; B.S.; M.S.; and Ed.S.

Carl A. Dent, physician: B.S. Union Pacific College, 1934; M.D. Loma Linda University, 1939.

Samuel G. Dent, chemist: B.S. Dillard University, 1941; M.S. University of Cincinnati, 1942; Ph.D., 1944.

Inez K. Edmonds, educator: A.B. Morgan College, 1920; graduate study at Rutgers State University.

Thomas Fuller, Colonel, U.S. Army: graduate of Risley High; B.S.; and M.S.

Wendall P. Holmes Jr., mortician: B.S. Hampton Institute, 1943; Eckels College of Mortuary Science, 1947.

Robert W. Kitchen Jr., teacher and accountant: Risley High class of 1939; A.B. Morehouse College, 1943; M.S. Columbia University, 1946.

Edward Life, attorney: son of Julia Minor Life.

Lois Life, R.N.: daughter of Julia Life.

Timothy McDonald III, clergyman: B.A. Berry College, 1975; M.Div. Emory University, 1978.

Joseph Patterson, scientist: B.S. Morehouse; M.S. Atlanta University; some studies in Switzerland.

Mahlon Rhaney, teacher at Florida A&M University: A.B. Dillard University, 1939; M.S. University of Michigan, 1943; Ph.D., 1948.

William Thomas, pilot: B.S. Tuskeegee Institute, 1959; 2nd Lieutenant USAF killed in T-33 crash.

Talmadge C. Tillman Jr., accountant, educator: B.S. Syracuse University, 1948; M.B.A. University of Colorado, 1949; D.B.A. University of Massachusetts, 1967.

Elliot V. Troup, ophthalmologist: B.A. Fisk University, 1959; M.D. Meharry Medical College, 1963.

Alfred Williams, 1st Lieutenant USAF: born on St. Simons Island.